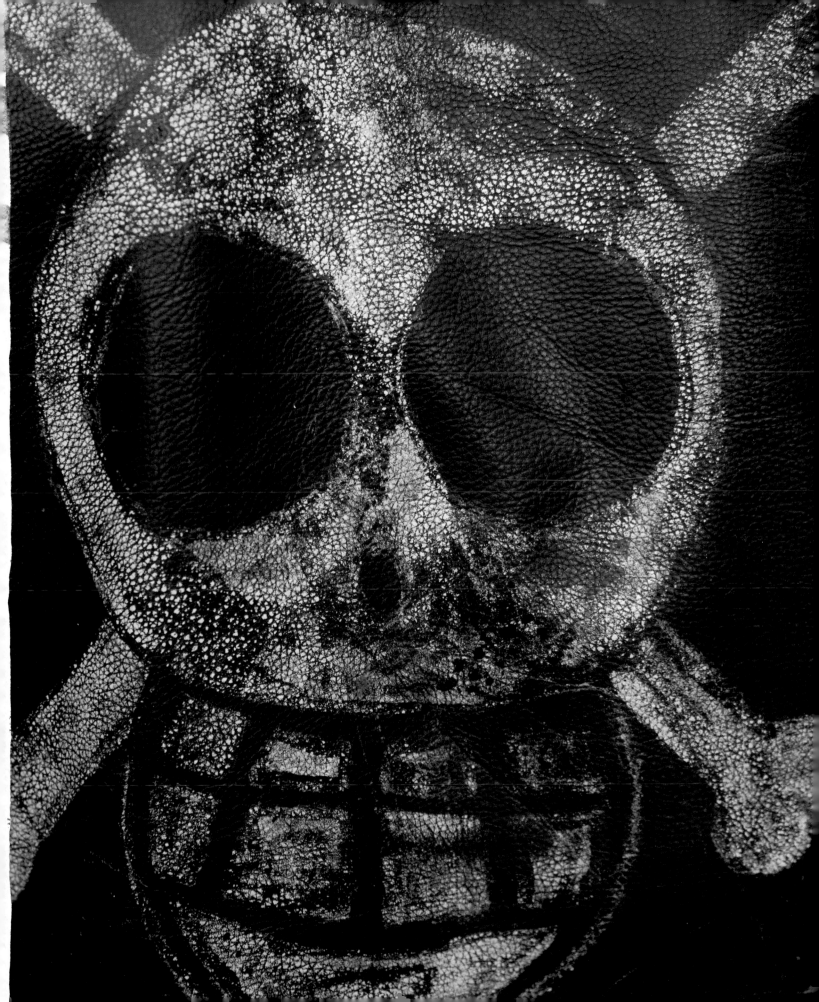

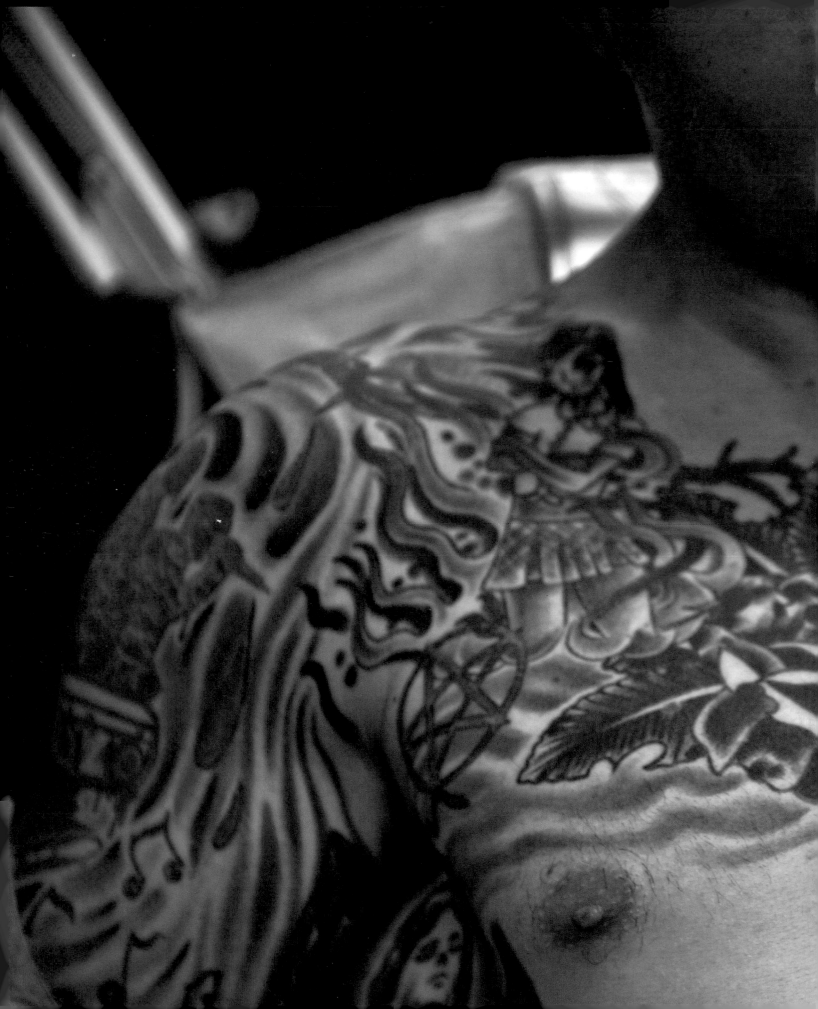

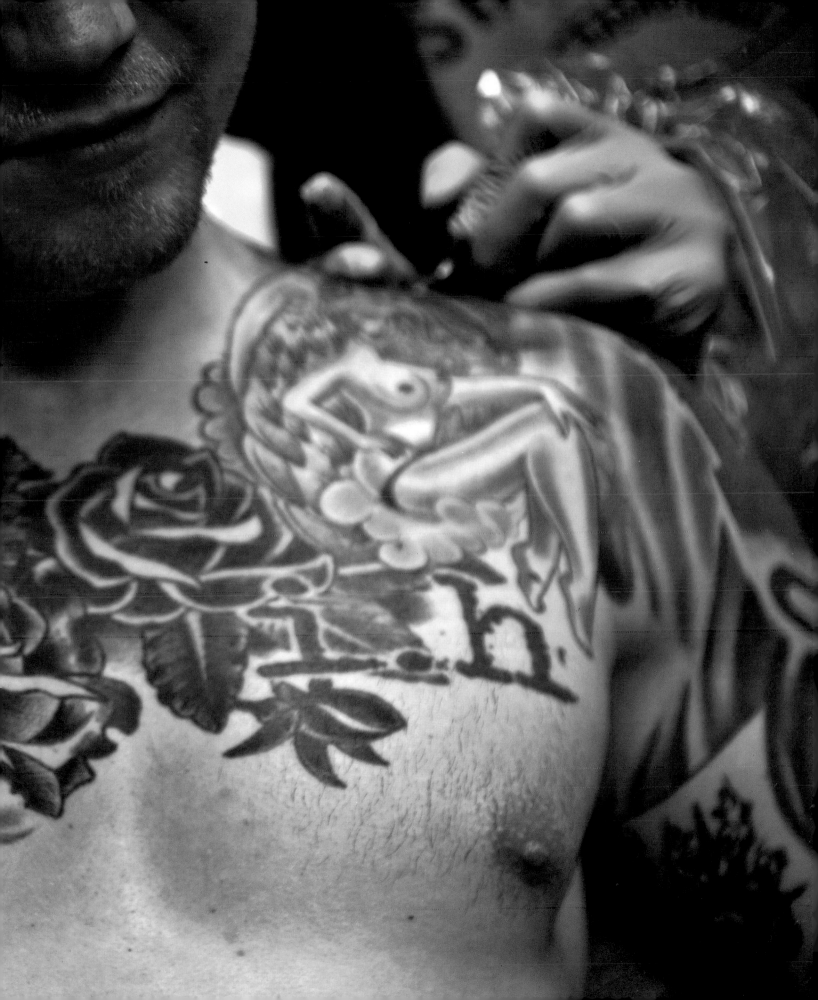

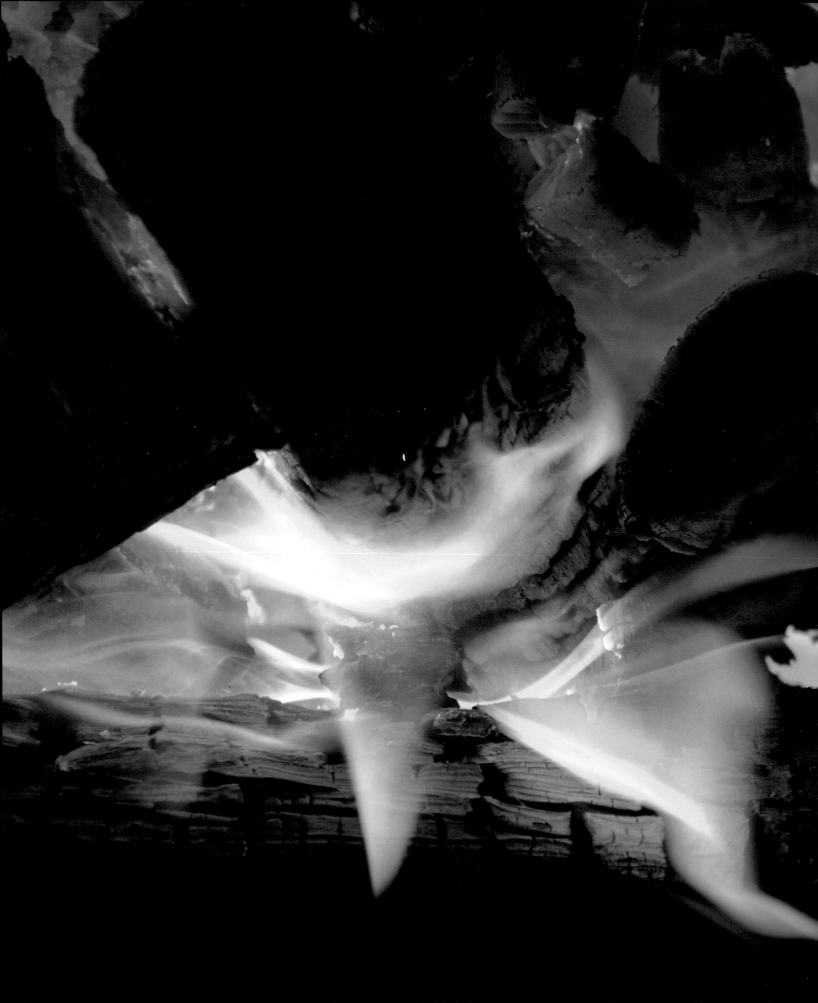

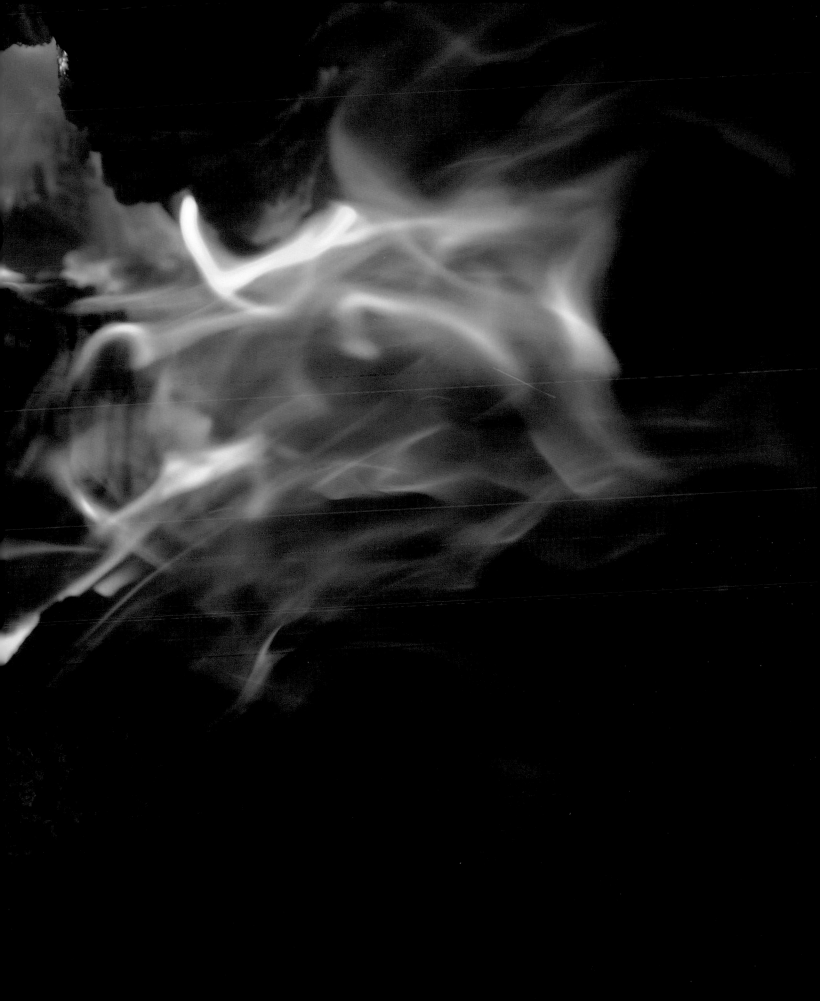

Tattoo

Ta=drawing, Toua=soul, personality.

Probably Polynesian in origin and means a mark of something important that has happened in a life and can be a metaphor for an emotional, internal event that has become visible on the outside skin. Doc Forest (actual name, Ove Skog) opened Sweden's first tattoo parlor in 1972. Today there are 800 parlors in the country and the most renowned are booked solid for the coming three years. Customers range from school teachers to bank directors.

Tattoos are increasingly visible in the streets of Stockholm. The rather secular, individualized Swedish society allows for people to create their own destiny, change themselves, and maybe even to enable them to feel more like themselves. And yet tattoos are not completely mainstream, and therefore sometimes evoke admiration and disbelief.

Hornets

Every single Swede is familiar with the term "getingsommar," referring to a summer with an unusual proliferation of stinging bugs of various species, including hornets, which occurs regularly after an unusually long winter with an abundance of snow, during which many fertilized female hornets, the so-called "queens," survive. If the following spring is a warm one, the queen can produce as many as ten thousand individuals and these stinging creatures are a force with which the local population must deal in a variety of ways.

Climate plays an important role in a country whose location is as far north in the hemisphere as Sweden. Authors like Stieg Larsson have used the seasons in his novels almost as characters that embellish the plotline because of the role weather plays in daily life. Even in twenty-first century Stockholm, the urbanite who— despite all available commodities— are subconsciously affected by the intense variations of light and dark, depending on the season. The cumulus clouds of summer against a bright blue sky or the misty yet bright pastel shades of late winter are as present now as they were in the times of rural forefathers.

During the short summer months the human beings populating this part of the world have to soak in enough light to last for a long winter when during a few months daylight is visible for only six hours. Long after the warm months are over, the quality of the past summer is a much-discussed topic during coffee breaks or any other occasion.

The fact that somebody has put a tiny hornet in a joint between two granite stones somewhere up on Södermalm Island could be an expression of the longing for summer, and may have even inspired Stieg Larsson to use hornets as a metaphor for Swedish climate and culture. This tiny ceramic wasp seems like a secret greeting. It is hidden on a granite wall up on Mariaberget Hill on Södermalm Island and provokes a mystery: At times, it disappears and reappears on a different spot along the wall and no one is quite sure how or why.

Fire

Fire has played a central role in the agricultural society of Sweden and several aspects of fire are important. First fire has been an important source of heat in a country that is far north and very cold in the winter months. It made food preparation possible for humble peasants during the winter season. In addition, fire has through history destroyed many towns in Sweden where traditional wooden buildings and entire neighborhoods could be swallowed by flames, thereby erasing homes and existences. So fire can be a metaphor for the fleeting nature of Swedish life, which can erupt and disappear in the lighting of a match...matches having been invented in Sweden.

April 30 is a special day in the Swedish calendar. Myth holds that during this night the line between life and death is thinner than on any other day. This is the day that also marks the end of the long winter. Bonfires were introduced several hundred years ago and the tradition of lighting a bonfire on the evening of this date, the evening of Valborg (Walpurgis Night), originated as a means to scare away wild animals and supernatural beings before letting cattle out of the stables to graze on the meadows after a long winter. It also symbolized burning the old to make way for the new. Just as many other old traditions with their origins in the rural society, bonfires are still cherished in modern Sweden, both in cities and in the countryside, thousands of people gather around fires throughout Sweden in the early evening. This night feels magic and explosive with a new beginning on the horizon.

TATTOOS

HORNETS

FIRE

First published in 2012 by

New York Office
225 Central Park West
New York, New York 10024
Telephone: 212 362 9119

London Office
1 Rona Road
London NW3 2HY
Tel/Fax +44 (0) 207 267 9739
+44 (0) 207 267 8339

GlitteratiIncorporated.com
media@GlitteratiIncorporated.com for inquiries

First edition, 2012

Library of Congress Cataloging-in-Publication
data is available from the publisher.

Hardcover edition ISBN 13: 978-0-9851696-1-9

Text by Elisabeth Daude
Design by Pau Garcia

Invaluable support in creating this book has been provided to the
publisher by VisitSweden. VisitSweden works to champion Swedish
destinations and the brand of Sweden abroad, in partnership with
the Swedish Tourism industry, and specifically with Stockholm
Visitors Board in promoting the beautiful city of Stockholm, where
renowned author, Stieg Larsson, did so much of his writing.

For more information and to plan your next visit
visitsweden.com

To stay updated
Facebook.com/swedentravel
Facebook.com/StockholmInFullGlory

Grateful thanks to the Stockholm Stadsmuseum/City Museum of
Stockholm for permission to photograph the artworks on pages
48/49 and 92/93.

Learn more about Christopher Makos and Paul Solberg
at their websites: makostudio.com and paulsolberg.com.

Printed and bound in China
10 9 8 7 6 5 4 3 2 1

TATTOOS

The Millennium Sweden

HORNETS

Photographs

FIRE

Christopher Makos Paul Solberg

Glitterati
INCORPORATED

New York | London

Contents

Puss, Puss

Puss, Puss. I know this is a totally strange way to start my introduction to this book, but after your first trip to Sweden, you will know exactly what I am writing about. My expectations had little in common with what I found there; much in the same way that, now that I think about it, Ingrid Bergman, Ikea, and Stieg Larsson seem to have little in common. You will be amused to know that *Puss, Puss* means Kiss, Kiss.

I have always been fascinated by the Nordic countries. Being of Italian/Greek descent and believing that stereotype that the southern countries are warm and romantic and conversely, that the northern countries by contrast are cold, serious, and aloof. I have come to realize that stereotypes are really of little use to any of us. Funny, because, Stereo-Type, to me, means seeing with your two eyes wide open, not shut.

After my first, "official" trip to Sweden for an exhibition of my photographs of Andy Warhol at the brand-spanking new, shining star of photography venues, the Fotografiska, I became aware of the real diversity in Swedish life. Being in Sweden for this exhibition became my window into my new understanding of the world of Swedish culture.

I guess I should start from the very beginning: Actually our SAS flight aboard a brand-new Airbus 340, with very cool attendants dressed in sharp royal-blue outfits and with the stewardess wearing baseball caps. As my photography partner, Paul, and I found our way to our seats, we did notice a festive air on the plane. Not that we could actually pinpoint what the, "special-ness" was about, but soon after take-off it became apparent that we were on the "Love Is In The Air" SAS Flight Experience. SAS, in conjunction with the Swedish tourist board, VisitSweden, and organized by Magnus Lindbergh and Andre Landeros Michel, created an in-flight pre-wedding party for two lucky young gentlemen. At a certain point, an extraordinary cake was presented to the young couple. Yes, you guessed it: We were celebrating in-flight what was to be a same-sex marriage in Sweden the next day. So if you are talking about how modern things are in Scandinavia, you are not just talking about the furniture. Welcome to Stockholm.

After a second and third trip to Stockholm and the notable release of the Stieg Larsson books and films, it became quite clear that there was an international groundswell of people talking about Sweden; and again, not just about design, but about people, and the people that are making the" new" image of what is Sweden. I have to say, I still love Abba; but what is so fascinating about what is happening now is that Sweden has become the, "it" country. We have all seen Big Ben, The Eiffel Tower, The Colosseum in Rome: It is now time for "Travel Reboot." One of the biggest little-known treasures of the world is Sweden; and one of the most important little-known treasures of Sweden is its people. The weather may be what makes the difference: It appears to be one nation in the bright and extended sunlight days of summer and an altogether different one in the cold, dark, winter months.

Both of these "nations" co-exist in a friendly union over their love of food, travel, and the arts. Along with their distinctive history, the current story is really about who the Swedes are today. In keeping to themselves for centuries, they have created a distinctive and attractive culture and place.

This book came about because of a confluence of events: a New York City photography exhibition organized by Magnus Lindbergh and VisitSweden to celebrate Sweden Paul Solberg and I took during the summer of 2011, and the idea on the part of our publisher that Sweden is undiscovered in book form and with the excitement of the Larsson books, people have a sense of the place, but no real visual document to consult. VisitSweden was in agreement that there was a place for a book of this sort for both the actual and the armchair visitor to Sweden—one that combined our iconic photographs with the prominent locations and themes in the Larsson books—and off we went on a final photographic foray, to capture additional artworks to include locations and sights that were so prominent in the minds of Larsson readers, but which had not before been captured in photographs for the public in monograph form.

The book is organized to flow from the beginning with the overall tourist view of the city; moving then to a view of the city as it might be viewed and experienced through the eyes of Stieg Larsson and his characters; and finally, an emergence from the storyteller's view, to one that would be undertaken by an actual Stockholmer visiting his or her hometown, with all the passion that Paul and I would show our hometown, New York City.

I hope that I have transmitted to the reader my sense of revelation and discovery so that each one is able see what I have seen and what is the Stockholm of today: Modern, current, relevant and absolutely delicious.

Christopher Makos

Bread

Bread is Sweden's Eiffel Tower. Good bread is hard to make, and takes years or sometimes centuries to get right. It's beyond a recipe, like a successful building is simply a good recipe unless people elevate it to something more. Human beauty can be the same. The space between the eyes and nose and how the skin lies over the skull can make for a pretty person, but it's simply a recipe unless there is something more.

Being Scandi-American I endured years of Nordic hymns and white cookies and fish soaked in lye. I was raised in an environment with a high level of misplaced nostalgia for anything Scandinavian. Although I grew a strong antenna for travel in my youth, the thought of another cold dark place, similar to where I was raised, didn't pull me in.

The Solberg family finally made the long voyage to the Motherland (minus one, I was in school) and returned in wooden clogs and folkloric sweaters; my sister even imported a native loom for weaving. Years after, the kitchen table conversations were still centered around the new Swedish crystal.

To wrap my head around my own northern journey was all the more challenging. These family recollections blurred and warped over the years, and in 2010, the opportunity came up for my own maiden voyage.

Makos and Solberg go to Sweden.

From the moment we stepped foot on our first SAS flight, any Nordic nostalgia couldn't compete with reality, which was fresh and new and unexpected.

Soon after settling into our seats and the first course of elaborate breads were served, a keyboard rolls out from a head of the plane into the business class cabin. The crew, on their second costume change, gathered around to sing, "I am what I am" to two sets of blushing American newlyweds. It was SAS's "Love is in the Air" flight, the first same sex wedding celebration on any commercial flight. A big white cake rolled out, as businessmen and families alike sang along as endearments were exchanged, it became a party of strangers. It was one of those things that to try to describe it sounds corny and ridiculous, but it caused an entire cabin of strangers to connect on this most inspired flight. Talk about united airlines.

After three astounding trips to Sweden in one year, looking back at that first flight, I realize that experience is most emblematic of Swedish culture. After having had the opportunity to see a good part of the world through my work, I learned that the Swedes are much more than the faint shadows of immigrants past. They're both practical and modern. They're low on fundamentalism and high on function. Whether it's a well-made chair or well-made community, all parts play an equal role to make it work. They're a people who live the motto "treat thy neighbor as thyself," without preaching it. Their morality isn't infused with religion, so when someone does something kind, it seems it's kind for kindness sake; sort of like a gift without a reason. The newspaper is left on the train for someone else. It's just what you do.

There are many faces of Sweden, depending on the season, and depending on the island. This book focuses mainly on a darker, moodier Sweden, particularly the two hours when the sun sets and the blue light floats through the streets as the long evening begins. Makos and I trace the steps of Stieg Larsson, inspired by the world he created, with Stockholm playing the leading role in his trilogy of mysteries. Like any interesting journey, in the shooting of this book we had our map but were occasionally distracted by the lighter side of Stockholm, a town of good hair-cuts and sincere eye contact. The lighter-brighter Stockholm is as much the "real Stockholm" as the darker picture story we tell in this book.

Stockholm is unique in that the cityscape is virtually untouched by war, rare to most European capitals. So you have this beautifully northern "ginger-bread" skyline. But once deeper into town, if armed with appropriate curiosity, you find a place full of sub-cultures and eccentricities and playful cuisine, unique to Stockholm.

One surprise was coming across a candy store with a beautiful typeface on its canopy, "Pärlans." We had to go in. There were a dozen or so young blondes in head-to-toe 1940s period clothing, pulling taffy, listening to Cab Calloway. What? Where are we? Seeing our wide eyes, they cleared the floor and legs started flailing against the floor, as the girls tossed each other around the room with the toffee bubbling in the kitchen. We had just entered the underground culture of "Swedish Swing." After hours of buttery taffy and hearing one of the leaders speak about their manifesto of Swing, we headed down the street to a "gothic spa," better known as a body-modification parlor called "Calm," where a trio of sincere young gentlemen, head to toe in ink and rings, kindly greet us as though we've entered a fancy doctor's office. With none of the severe attitude to accompany their severe exterior, they bring us on a tour of the "suspension room," where we learn one can unwind by hanging from the ceiling by the skin of one's back. I couldn't wait to tell the family this Swedish story.

Another block away we bump into "Flux Shop," a surrealist art shop, "erasing the boundary between art and life," where a handsome store clerk isn't just there to ring up a sale, but engages us with his philosophy of art and commerce and his personal manifesto; blowing our minds, making us question everything. And that leads me back to bread.

Garbo, the Bergmans—Ingmar and Ingrid—they're all great ambassadors, but bread is the real princess of Sweden. We all know if your bread is bad, you have nothing. All the great cultures of the world have one thing in common: good bread. If you're a bread enthusiast, and you have not yet visited Sweden, your best bread days are ahead of you. And leave the clogs at home.

Paul Solberg

Fresh and New and Unexpected

The City of Stockholm, the Queen of Lake Mälar, the "Venice of the North," The Capital of Sweden: Stockholm is a modern European city with trend-conscious and, at times, trend-setting inhabitants.

Stockholm offers a wide variety of aspects. It is a city of contrasts: Always on the move and yet relaxed. Completely urban and yet with surprising hidden enclaves reminiscent of a small town. Buildings with historic splendor reflect abundance and affluence as well as structures that remind of times of hardship long left behind. The density of a big city and the omnipresent surfaces of water, the Baltic Sea and Lake Mälar, penetrating the city and visible everywhere, thereby giving any observer or passerby, any user of the city, the possibility of being enticed by its never-ending mobility and depth.

And there is the Northern light, this unique way the sun lights up the city and the countryside: bright during the never-ending days of summer and helped by bright white snow to illuminate during the winter months, mellow during autumn, and misty pastel-colored in spring.

Stockholm Sites Made Famous by Stieg Larsson.
*Indicates fictional character reference, although site exists in Stockholm.

Sites	Address and location on map
The Pub Kvarnen	Tjärhovsgatan 4 > **A**
Lisbeth Salander's elegant apartment*	Fiskargatan 9 > **B**
7-Eleven	Götgatan 25 > **C**
Millenium's editorial office*	Götgatan 19 > **D**
Adat Jisrael Synagogue	Sankt Paulsgatan 13 > **E**
Mellqvist coffee bar	Hornsgatan 78 > **F**
Lisbeth Salander's first apartment *	Lundagatan > **G**
Mikael Blomkvist's home*	Bellmansgatan 1 > **H**
Rådhuset - The Court House	Scheelegatan 7 > **I**
Monica Figuerola's apartment*	Pontonjärsgatan > **J**
Police Headquarters	Kungsholmsgatan 37 > **K**
Nils Bjurman's office*	St. Eriksplan > **L**
Nils Bjurman's apartment*	Upplandsgatan > **M**

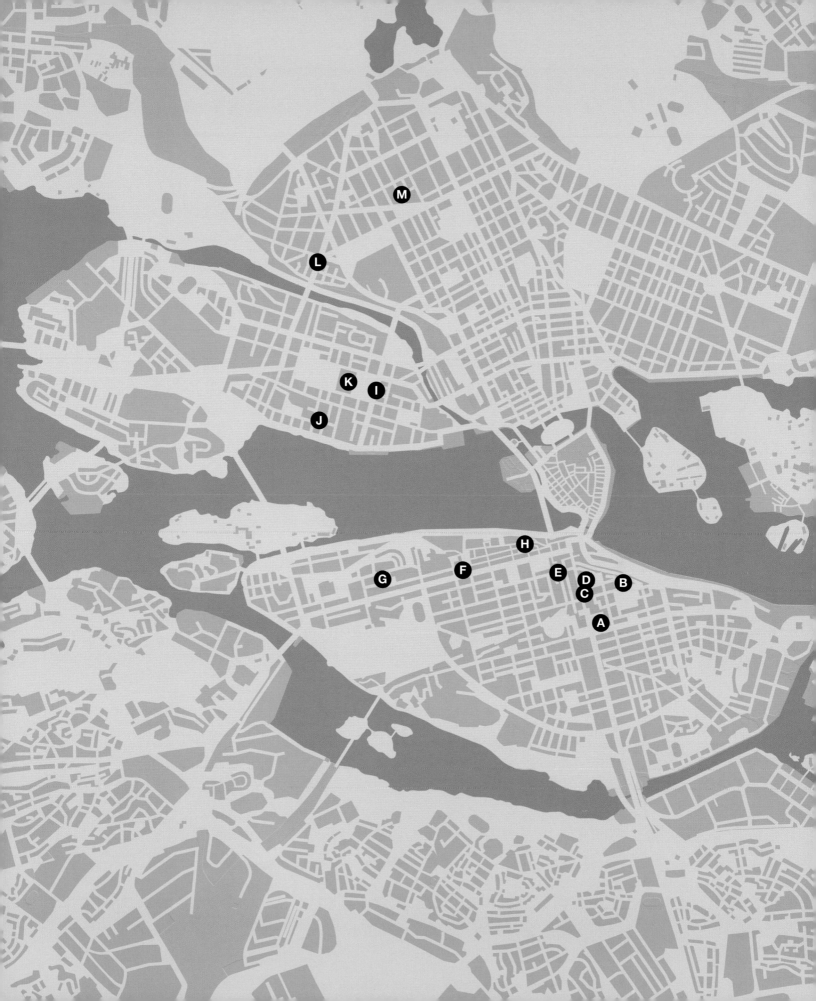

Left: The clock on top of the
Åhléns department store at the
southern end of Götgatan Street
has been a well-known landmark
on Södermalm ever since it was
constructed in 1942. It is crowned
by the well-known symbol of
Sweden: the Dala Horse.

Right: Slussen subway entrance,
Södermalm Island.

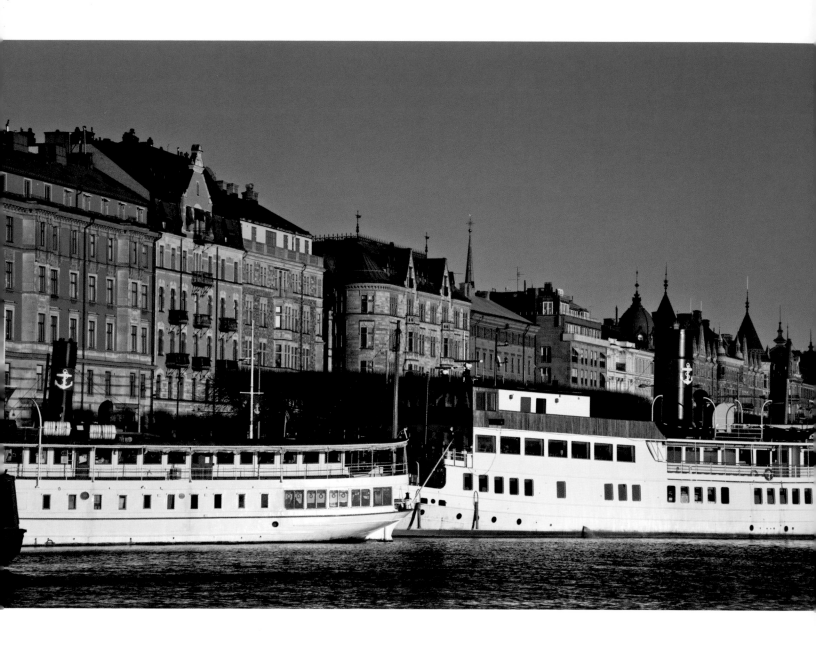

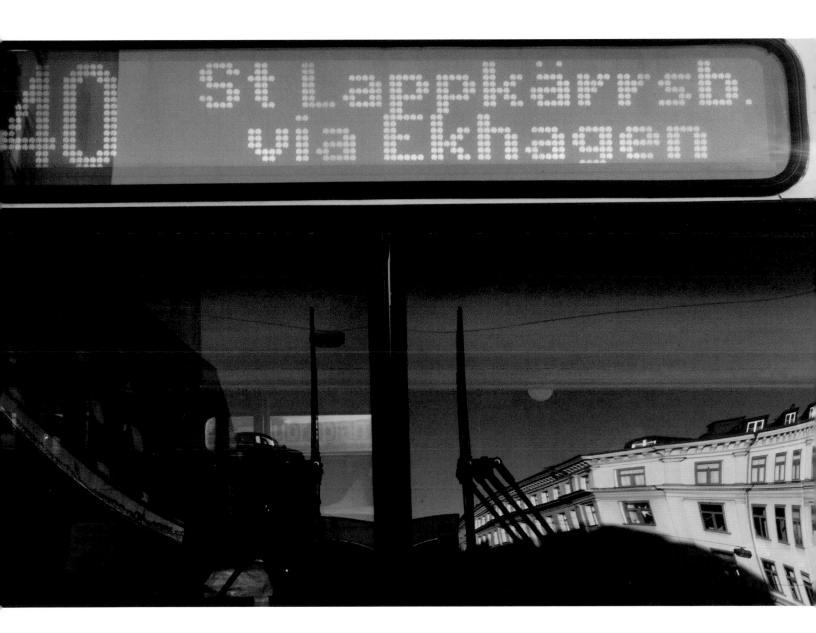

Left: View across the late 19th-century facades of Strandvägen Street in the elegant Östermalm neighborhood. **Right:** Bus 40 stops just outside the Local Court House. Stieg Larsson made this bus famous as an escape route in his novels.

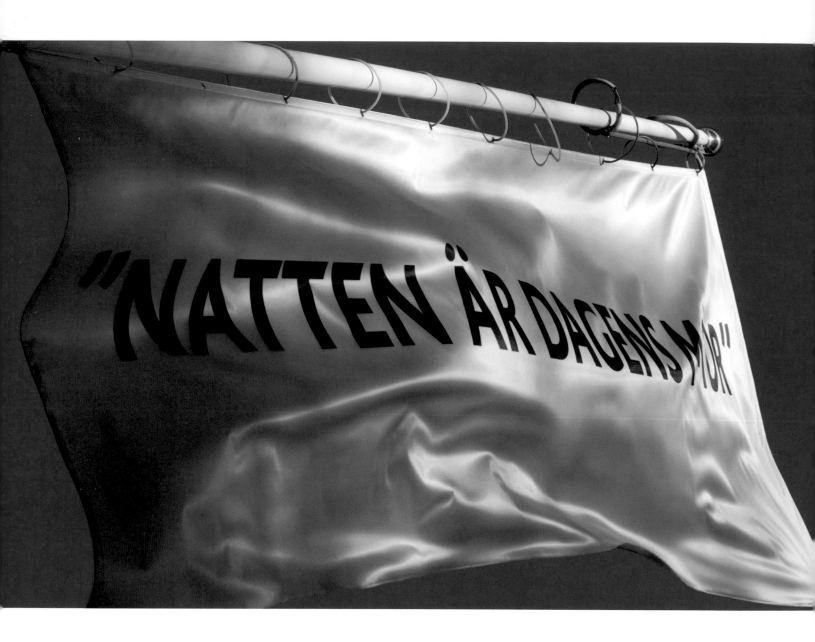

National Theatre banner announcing the
play, *Natten är dagens mor (The Night is
the Mother of the Day)* a modern Swedish
classic by Lars Noren.

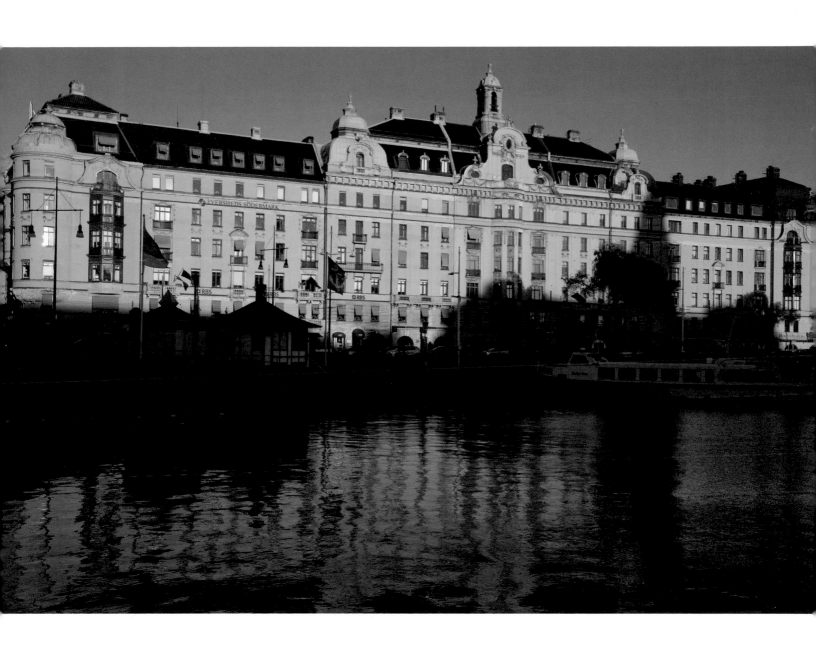

Strandvägen Street 1-5, a combination
apartment and office building
dating from 1904.

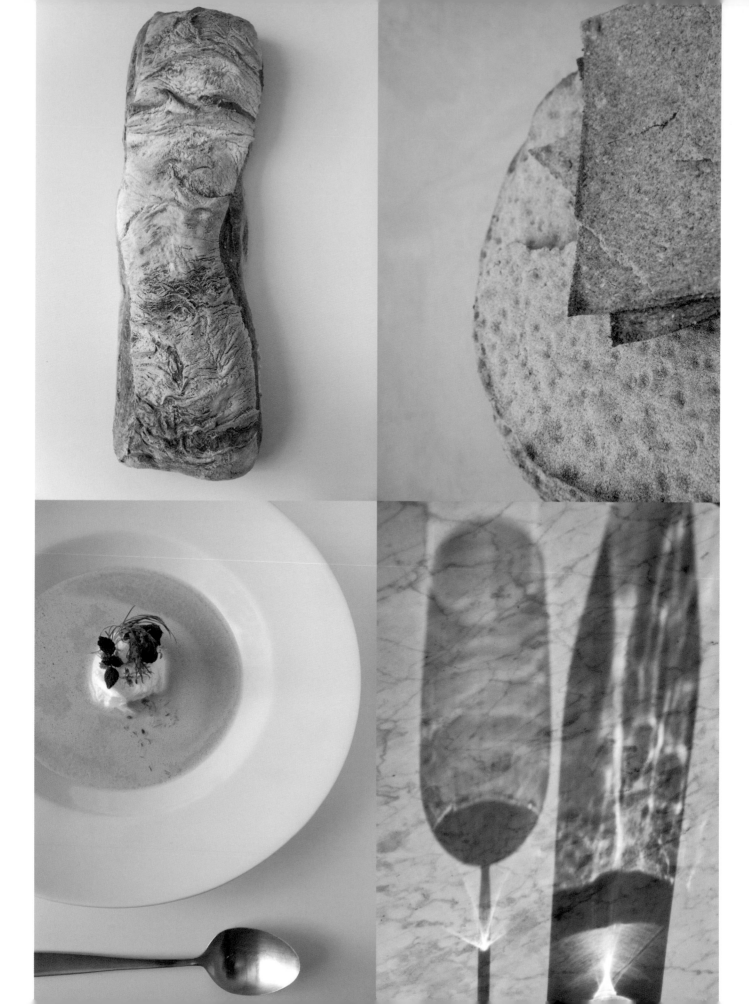

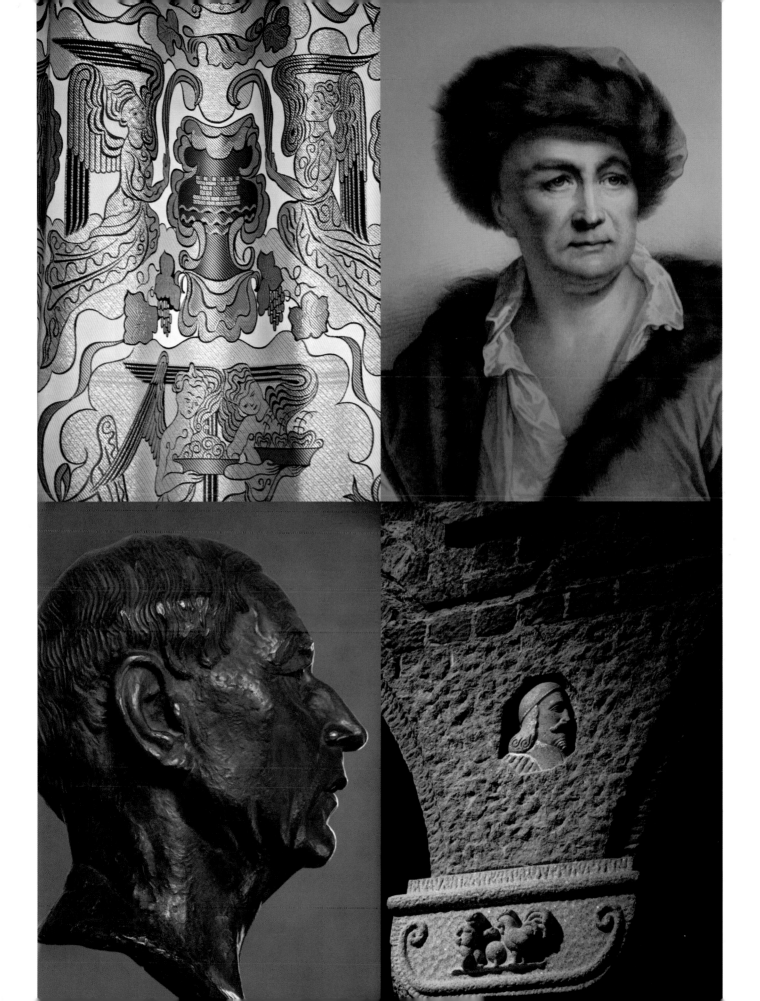

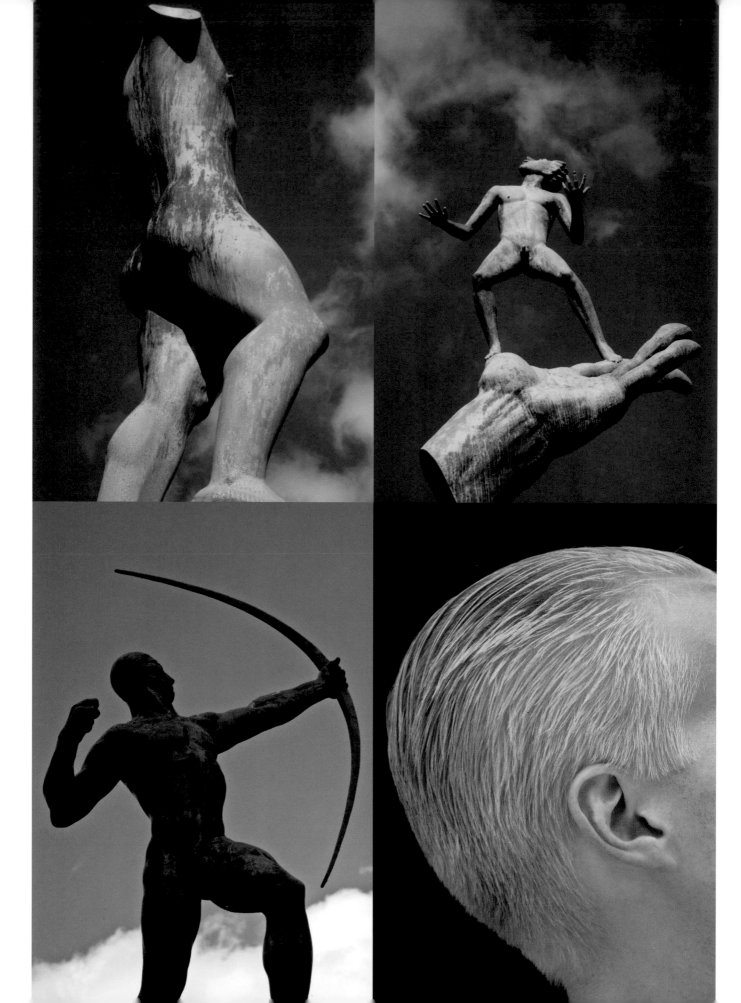

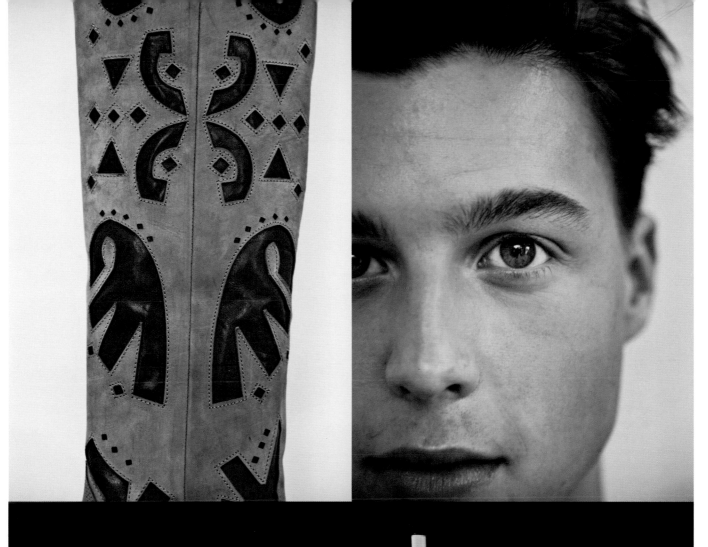

Page 33: Impressions from Stockholm City Hall, a landmark building inaugurated in 1923. Upper left: Silk brocade tapestries designed by textile artist Maja Sjöström (1868-1961) with the two towers, the medieval city emblem, originally woven at Bevilacqua in Venice, Italy, copies woven in Hangzhou, China. Upper right: Unknown man. Lower left: Bronze bust by Anders Jönsson (1883-1965), portraying the architect of City Hall, Ragnar Östberg (1866-1945). Lower right: Axel Oxenstierna, Lord High Chancellor of Sweden between 1612 and 1654, high relief by Gustaf Sandberg (1876-1958) located on a pillar in the Blue Hall of City Hall.

Page 34: Statues at Millesgården Sculpture Park on Lidingö Island by Swedish sculptor Carl Milles 1875-1955). Upper left: *The Sun Singer*, 1926. Upper right: *The Hand of God*, 1953. Lower left: *The Archer*, 1919.

Page 35: Upper left: Modern high-heeled boot design inspired by Sami iconography. The Sami are a native people in the north of Sweden. Lower left: The national pastry, The Princess Cake (*Prinsesstårta* in Swedish), a traditional Swedish cake consisting of alternating layers of airy sponge cake, whipped cream and thick pastry cream all topped with a skin of marzipan. The original recipe first appeared in the 1930s *The Princess Cookbook*, published by Jenny Åkerström, a teacher of the daughters of Prince Carl, Duke of Västergötland.

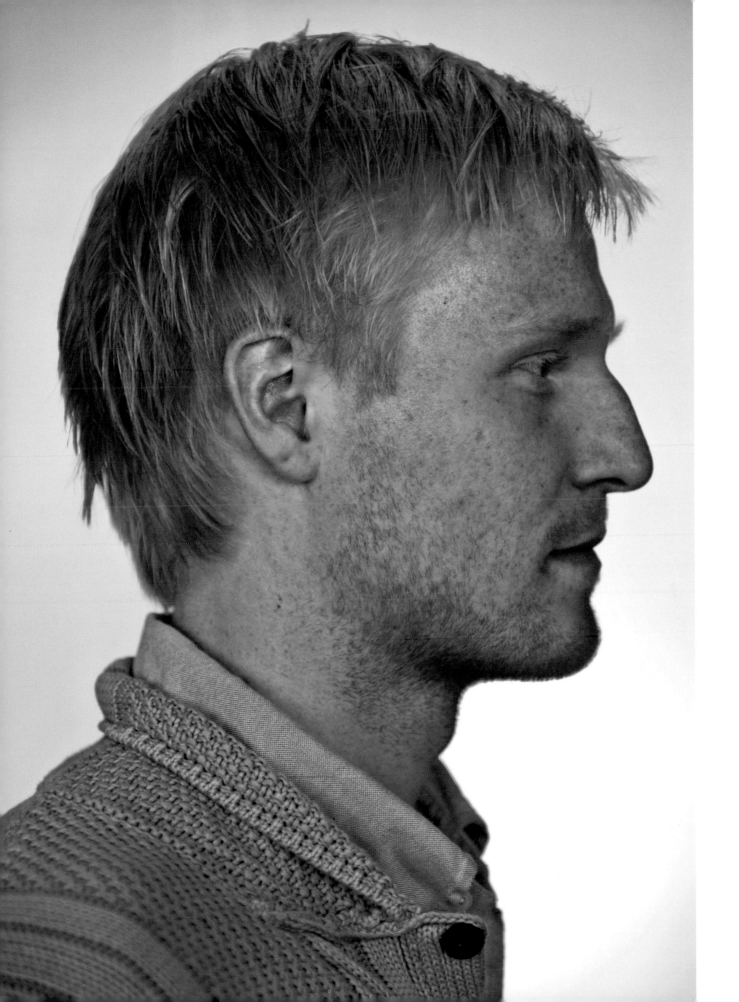

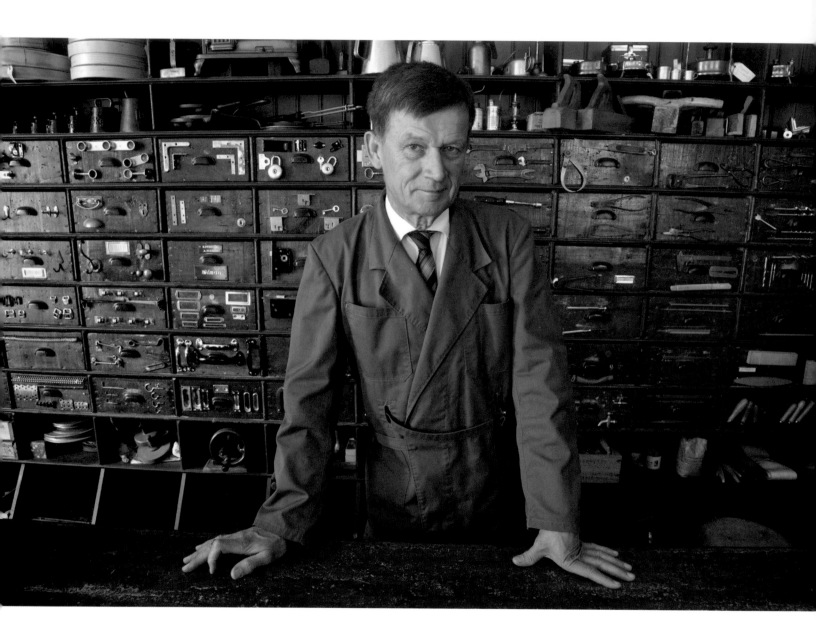

Inside the old hardware store at Skansen
Open Air Museum, the entire interior of which
and all items were brought to Skansen from
a store that closed in 1994. The man behind
the counter is a former hardware store owner.

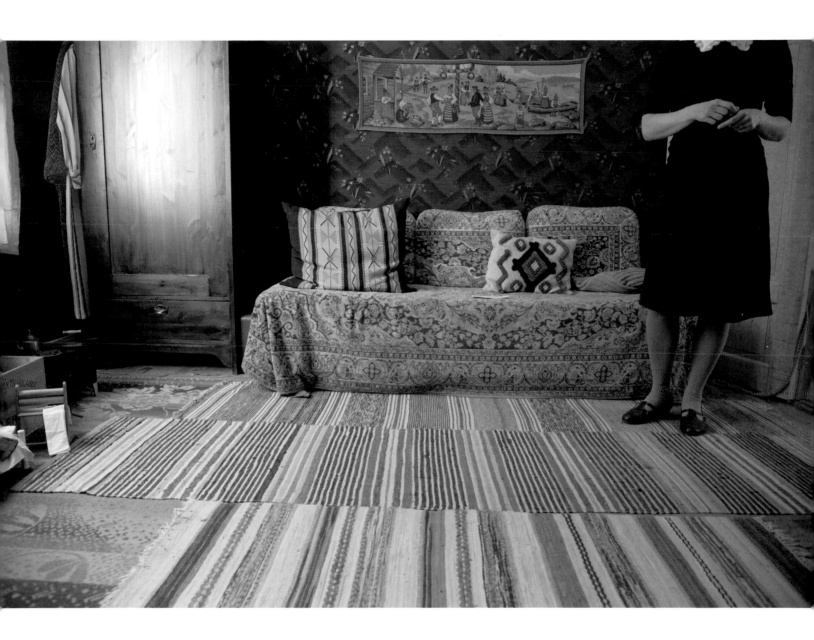

A home interior recreation at the Museum,
reflecting the typical 1930s Swedish interior,
showing a rug made in the usual weaving
style of the period.

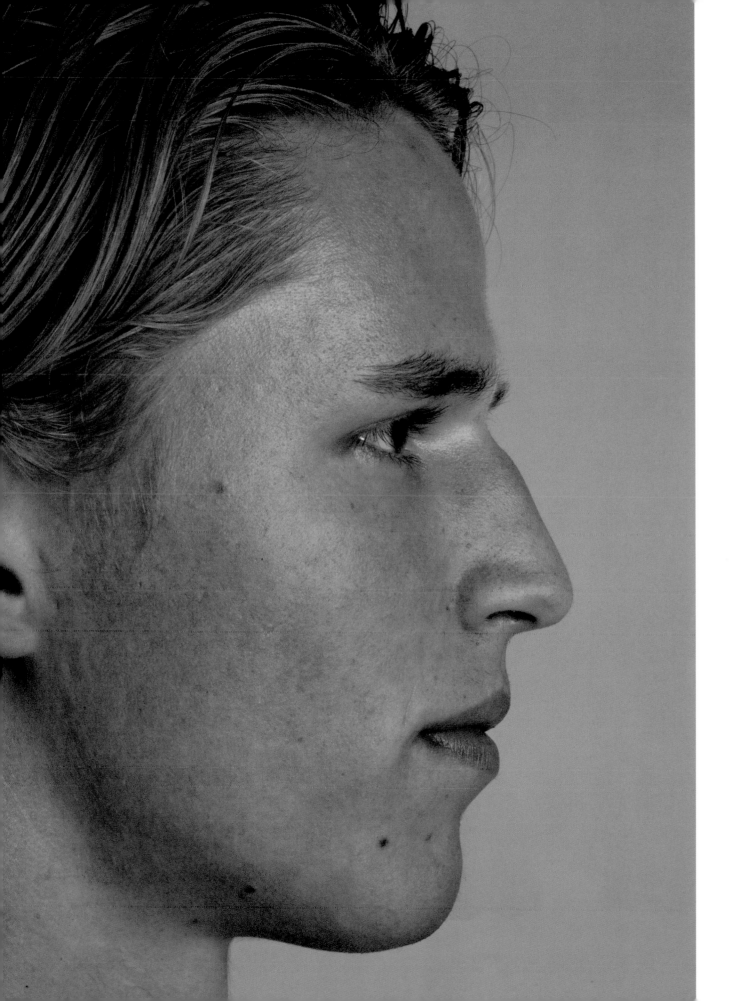

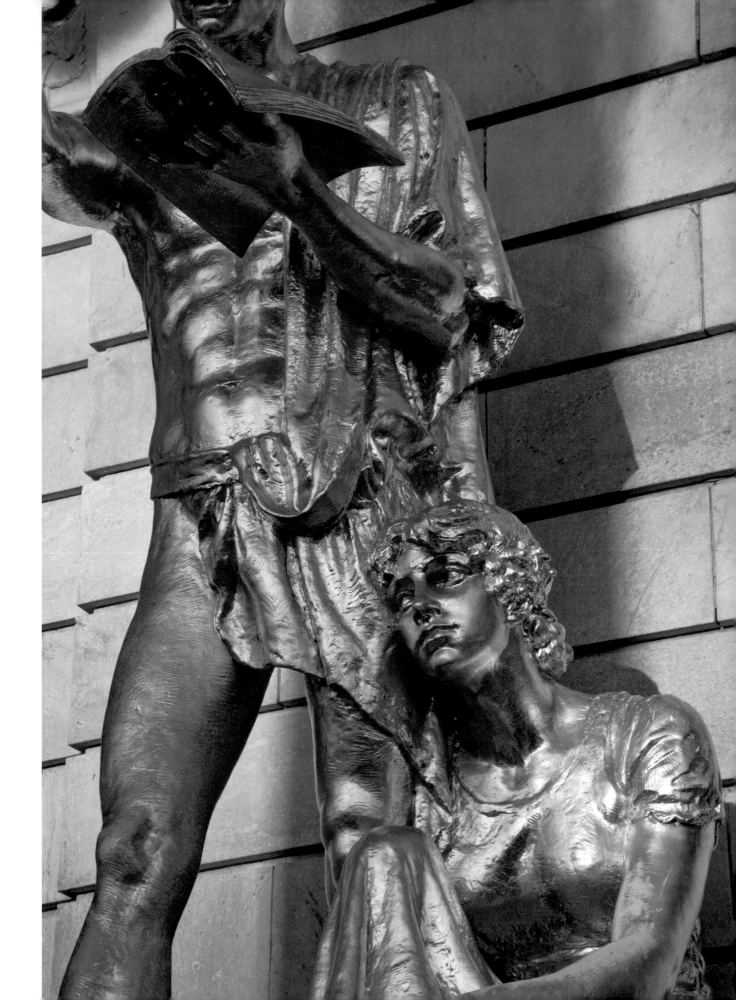

Previous pages: Gilded statue by artist John Börjeson (1835-1910). This sculpture stands in front of of the Royal Dramatic Theatre, designed by architect Fredrik Liljekvist (1863-1932), and is considered a masterpiece. It was inaugurated in 1908. Right: Gilded lamps outside of the Royal Dramatic Theatre.

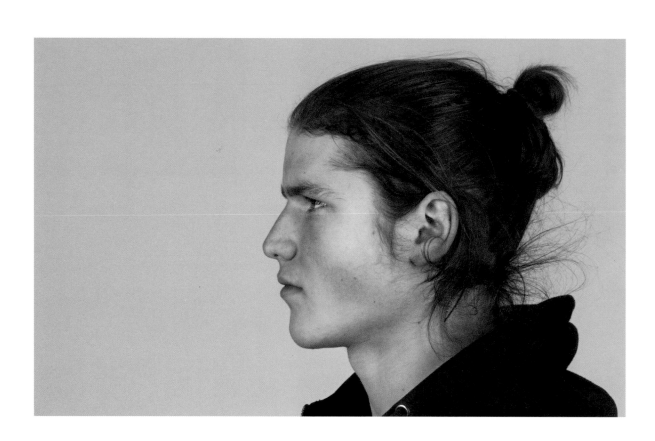

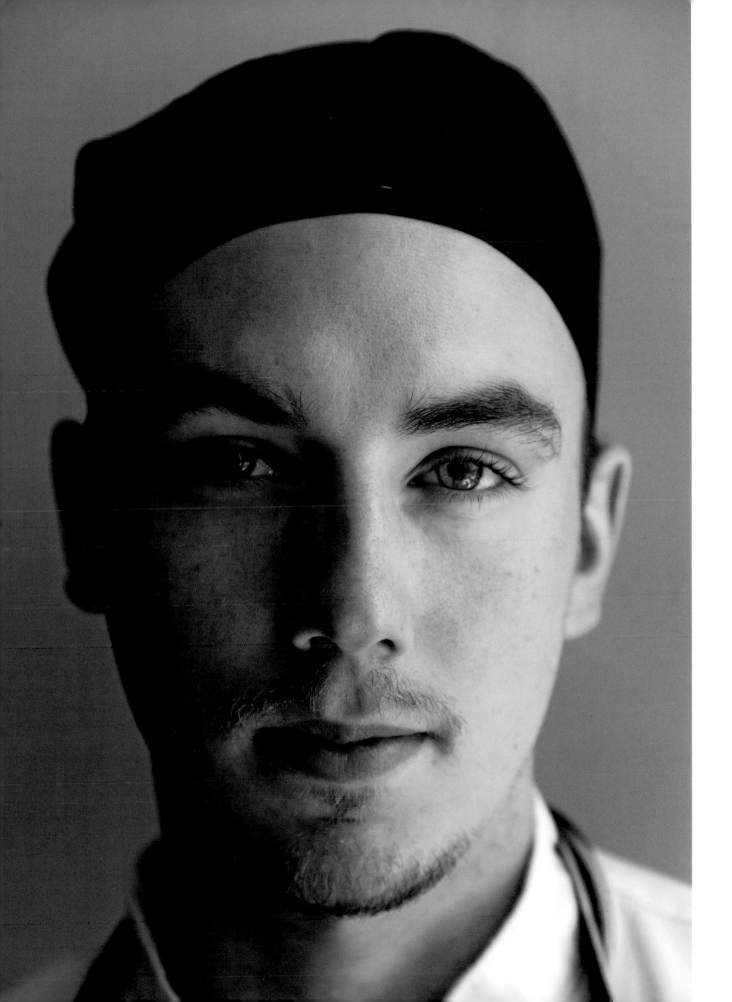

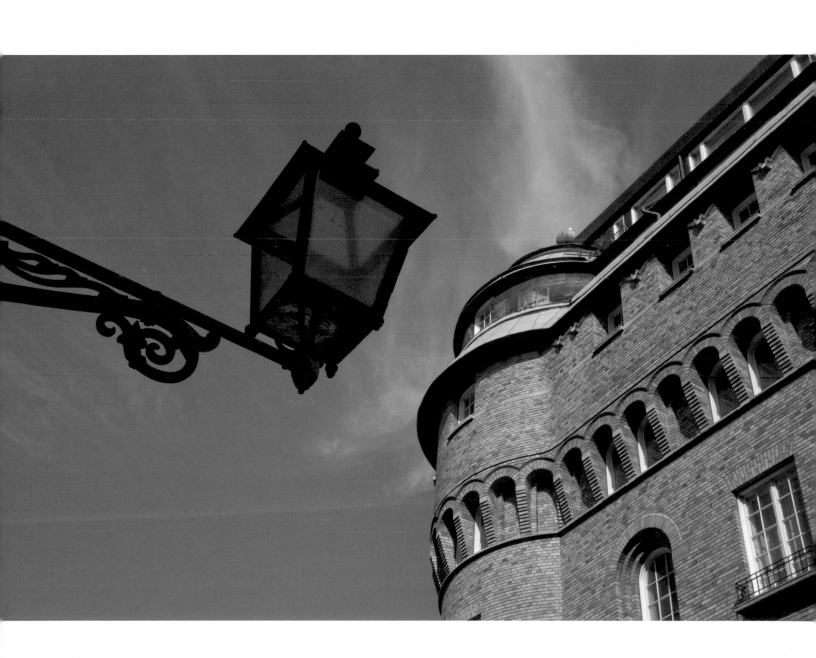

Previous pages: Many of Sweden's population make Stockholm, the capital, its hometown. And yet, today, in the second decade of the new millennium, the city has been able to keep some provincial touches to it, along with being a big city. It is proud of its past, maintaining and respecting the considerable amount of public and private historic buildings from seven centuries. New generations of inhabitants transform and adapt them to their needs, often restoring them on the outside to what they looked like when they were first built and on the inside providing them with all modern features. An ever-increasing supply of well-stocked vintage furniture stores and vintage clothing boutiques are found throughout the city and help younger Stockholmers satisfy their nostalgia for "home" if they were not raised there. On the other hand, select modern buildings and considered contemporary interior design complete the esthetic appeal of the city. Public art, modern and traditional, well-crafted, can be found in many places.

Next page: The Golden Hall in the City Hall of Stockholm. Mosaic design by Swedish artist Einar Forseth (1892-1988) This is the venue for the after-dinner dance of the yearly Nobel Prize Banquet. It is decorated with eighteen and one-half million mosaic tiles and features a wealth of themes. The central image in the back represents the Queen of Lake Mälar, an allegory of the city of Stockholm where Orient and Occident meet. Note the Statue of Liberty in the lower left corner.

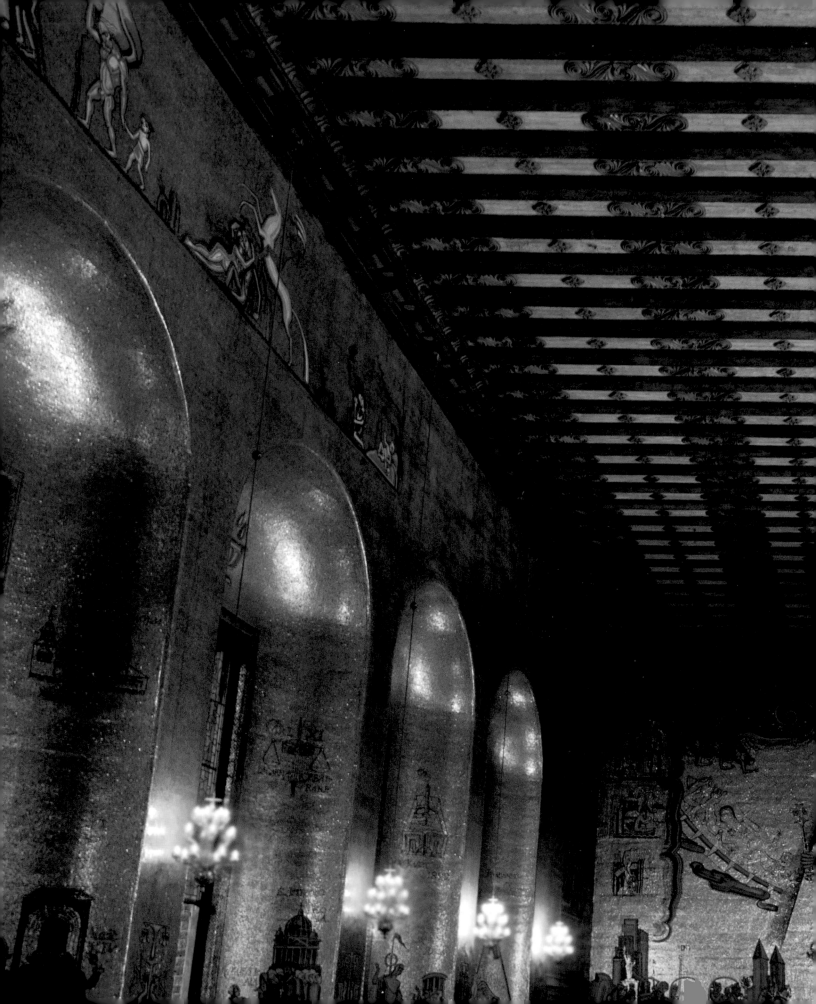

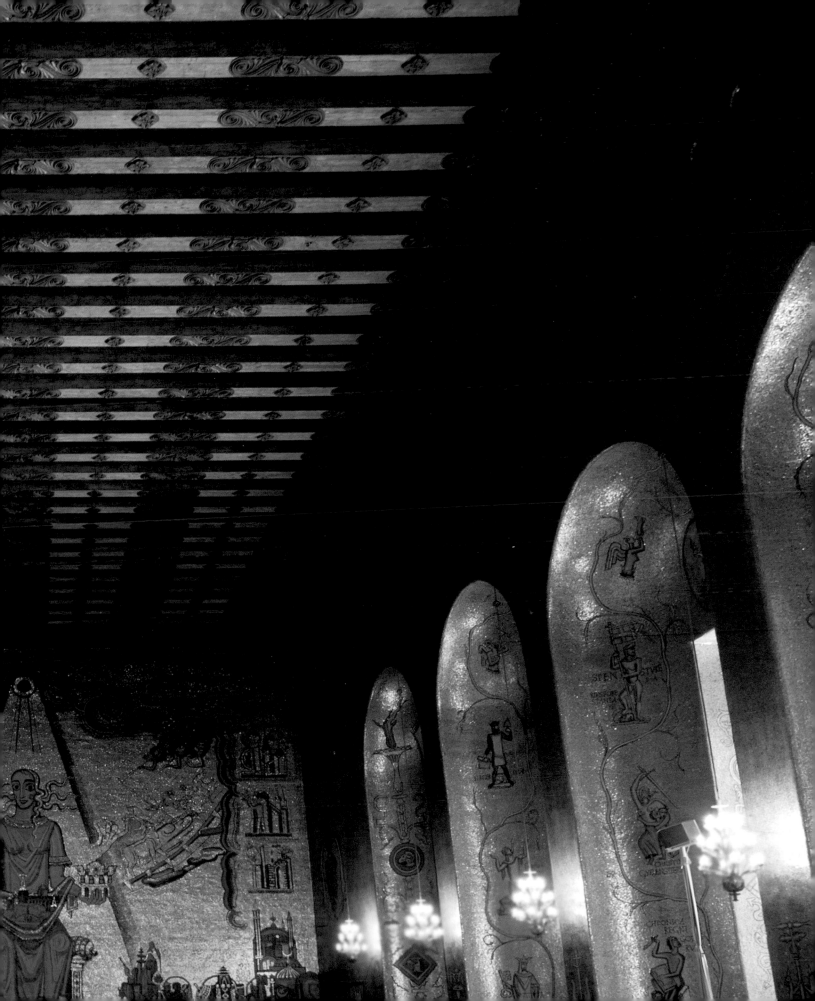

P56

Armed with the Appropriate Curiosity

The Swedish capital is the largest city in northern Europe with close to 2.1 million inhabitants living in the greater Stockholm area. The country is the third largest in Western Europe, yet with a population of just under 9.5 million, most of whom live in the south and along the coastline. More than sixty percent of the country is covered by forest with a scattered village or town in the midst. In just 150 years Sweden has transformed from being a nation where more than ninety percent of the inhabitants lived in the countryside and subsisted on whatever the soil could offer to making the decision to entirely change their lives by emigrating (more than 25% left the country in the late-19th and early-20th centuries) to being a nation where more than 85% live in towns and cities.

Both urban and rural life is much different from what it was one hundred years ago. The population today enjoys a broad basic education, which gives them a natural self-confidence. The inspiration and immigration of diverse cultures has made people open-minded. Respect toward the rights of children is laid down by law. More than 80% have access to the internet at home and almost everyone owns a mobile phone.

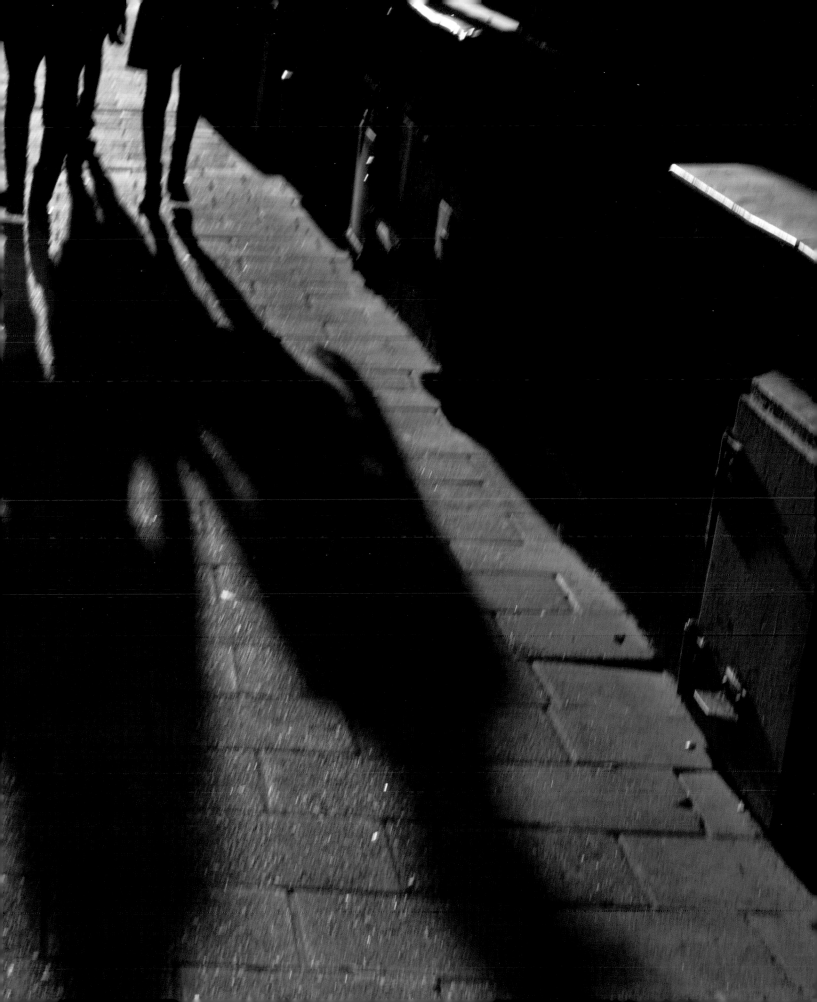

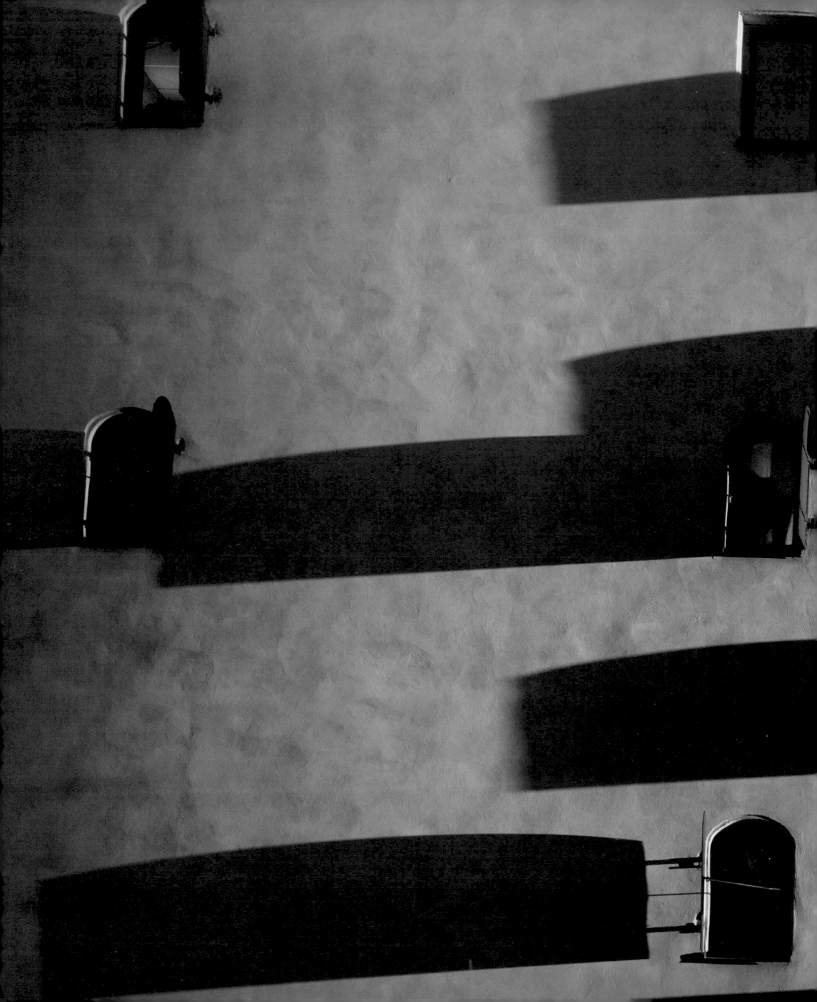

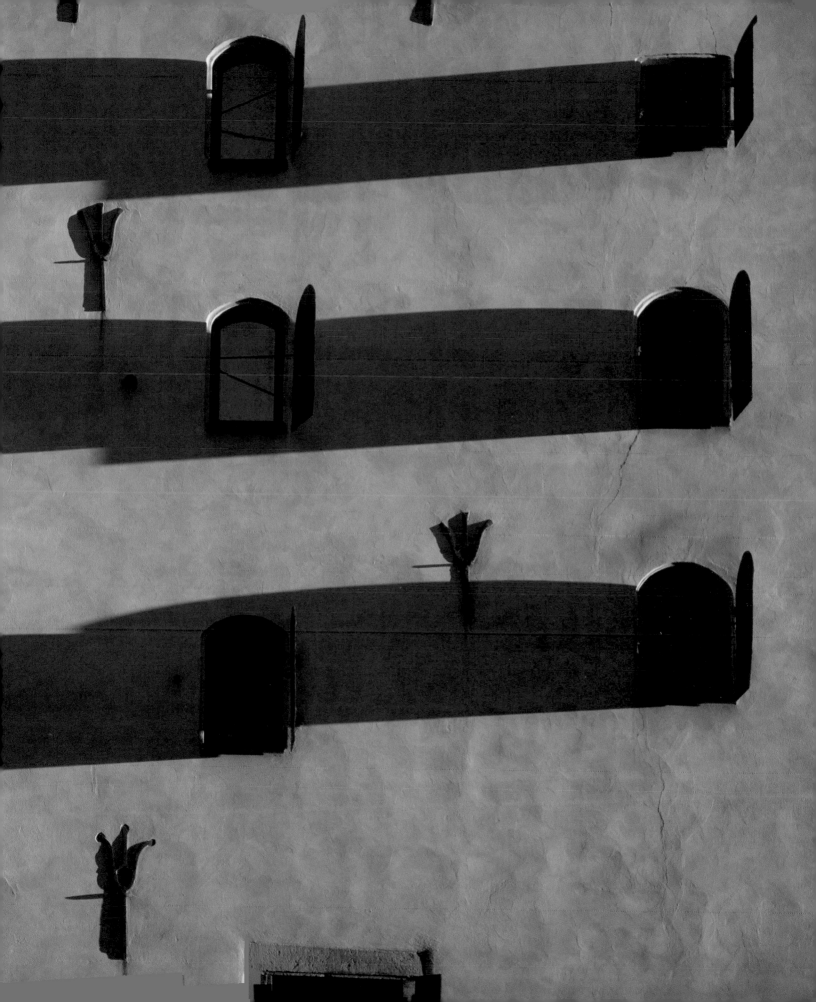

The Long Evening Begins

Journalist and author Stieg Larsson has his roots in the rural areas of the far north of the country, but spent the greater part of his life living in Stockholm. Led by his curiosity, he also was rather well-traveled. In the three best-selling crime novels he wrote within only a few years, he continuously includes real and fictional geographic locations into the action. Being familiar with a wide variety of countries, towns and landscapes, he uses his knowledge to intertwine these locations into the plots of his novels. With much of the action taking place in his hometown, Stockholm, the city plays a central role in his works. He knows the city well and likes to explore it. In the novels the city actually becomes a protagonist in itself and frequently leads the action forward.

Following his trail in the novels, riding the subway, walking on the cobblestone streets, admiring the facades and public art, watching people interact as do the characters in the novels offers the possibility to get even closer to the world created by him: A world that combines fiction and facts, a world where fiction at times seems as if it were real because the surrounding components actually are true and do exist. This is a world where the buildings, the sculptures, the pizza brand, the street addresses, the restaurants, the cafés, and even some of the human beings who appear in the novels are actual. Yet, only at times. Readers of his novels and tourists alike may wonder, "Is this real, or not?" It all seems so ordinary, so normal.

Many of the characters he describes are rather ordinary as well. The author offers the reader the full-facetted world of people one would encounter on the streets of Stockholm or any other large city, young and old, tall and tiny, beautiful and ugly, kind and evil. These people have a variety of occupations and may be a journalist, boxer, police woman or man, industrialist, hacker, politician or street cleaner.

Others are rather out-of-the-ordinary and therefore less likely to be encountered with the same frequency as former spies, bikers, or corrupt agents. The mix of normal spiced with the unusual, both geographic and human, absorb the reader and make the distinction between fact and fiction diffuse.

Yet even in his fiction, Stieg Larsson always remains the journalist who sees it as his professional duty to describe society with its lights and shadows and uncover existing injustices. He has a pronounced sense of right and wrong, he is continuously defending the weak. He is aware of the ethics of journalism. He is inspired by what has happened and happens around him, he observes all kind of events with great interest. He is sensitive to incidents and weaves what he has absorbed in large and small portions into his writing. And it seems as if the ink keeps flowing quickly, the words literally pour onto the paper. As a reader one perceives his pleasure of writing.

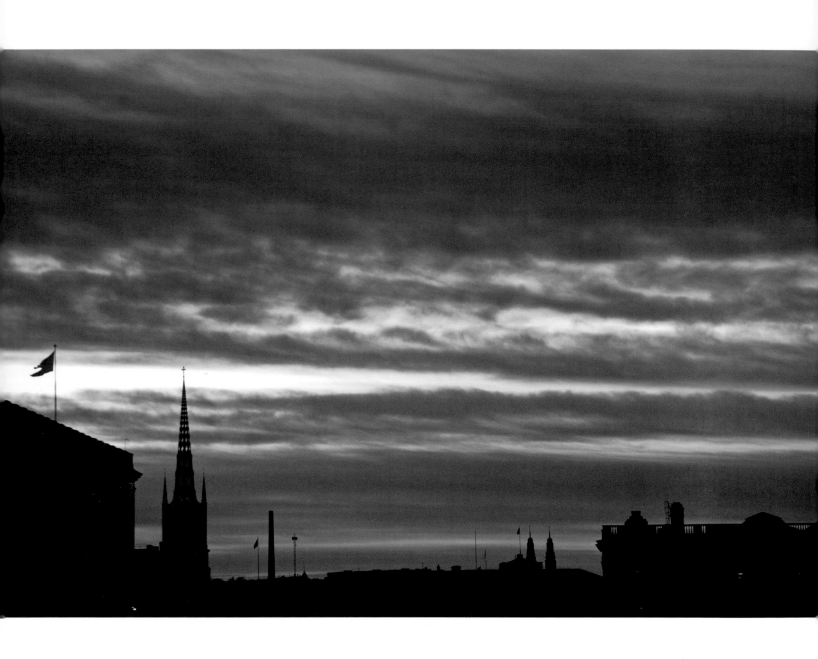

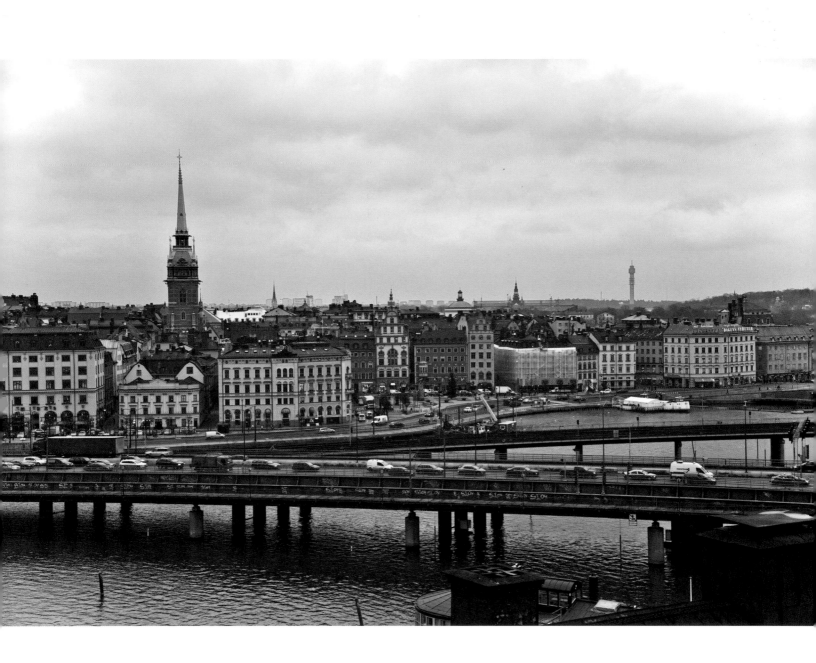

View toward Old Town and Slussen (the lock)
from an attic apartment on Bellmansgatan,
which Larsson used as a home location for
his journalist protagonist.

Pages 70-73: The Archipelago. Stockholm itself is part of the archipelago. The area consists of more than 30,000 islands made up of granite rock and forests off Sweden's east coast. It is today a recreational area much visited during the warmer months by Stockholmers in search of silence, relaxation, proximity to nature, and life as it once was. Living in a sailing boat or in a cottage has become the retreat for many of the inhabitants of the capital.

Page 76-78: Old Town (Gamla Stan) is where Stockholm was founded as a trading village in the thirteenth century. It is made up of four small islands in the very heart of the city, with a quaint main square on the central island. This is one of the main venues that coffee-lovers go in search of a good cup in one of the many cafes. The Swedes are heavy coffee consumers, outranked in their consumption only by the Finns! No other neighborhood is as beloved by its inhabitants as Södermalm (in short, Söder) the Southern Island. Once the poorest area in town, adjacent to the harbor and filled with factories, apartments on Söder are today much desired. Architecture is heterogeneous and ranges from the seventeenth-century palaces, entire blocks of eighteenth-century landmarked wooden dwellings, and 1960s concrete blocks. The connection between Old Town and Söder is the Slussen clover-leaf system created in 1935, with its pedestrian tunnels, providing an urban experience not to be missed. This is also the area of the city with the highest granite elevations, offering stunning views of the entire city, the many islands, and the expanses of water. Creativity is omnipresent with subcultures of all kinds, design, music production, fashion, tattoo studios, health-food stores, cafes, clubs, pubs, and bars, offering a variety of activities to both resident and visitor. "Live and let live" is the motto here.

Left: View of Old Town with St Gertrude's Church on the right, and cars crossing on the ever-busy Central Bridge from downtown towards Södermalm.
Right: Eighteenth-century houses on Mariaberget. This is the hilly part of the island of Södermalm and contains many buildings that are part of the city's cultural heritage.

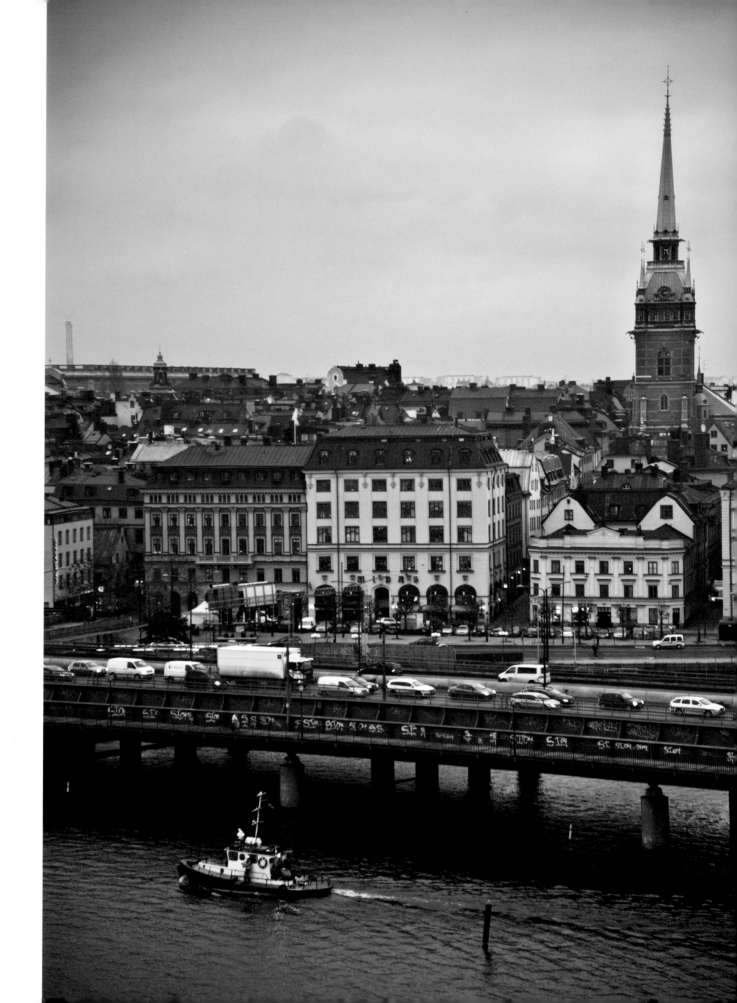

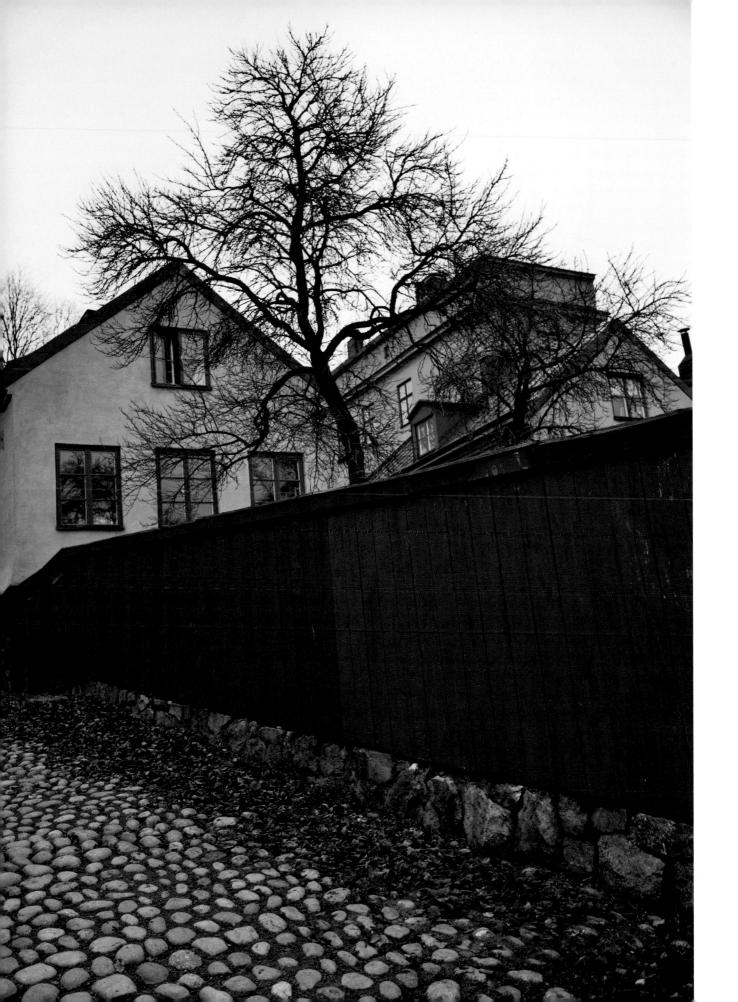

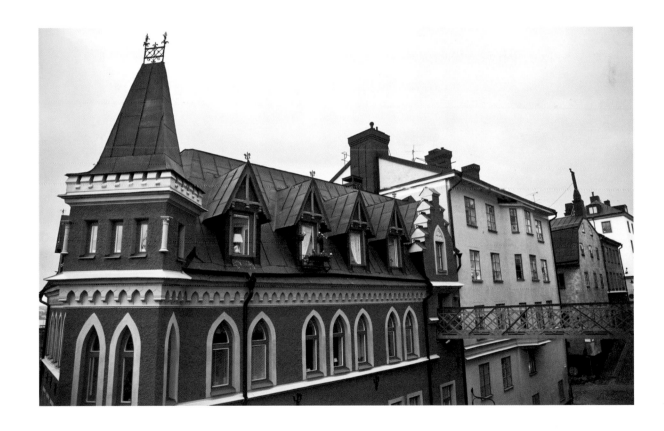

Left, above and following is the 1888 building
Stieg Larsson used to house his protagonist.

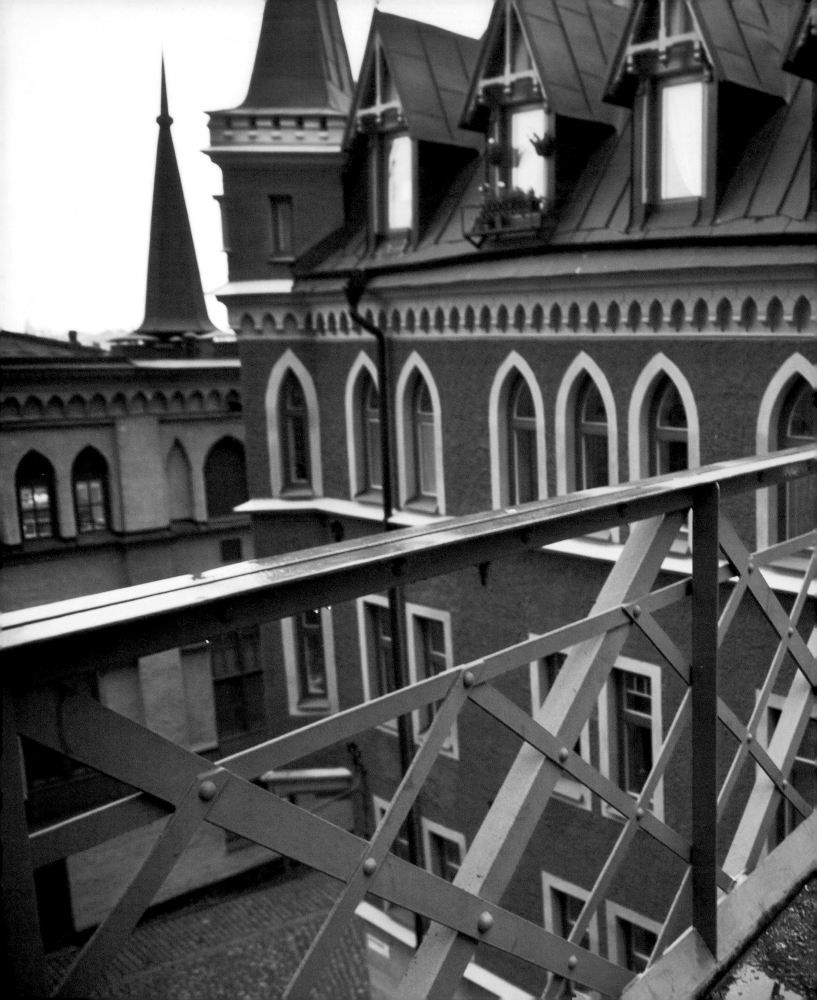

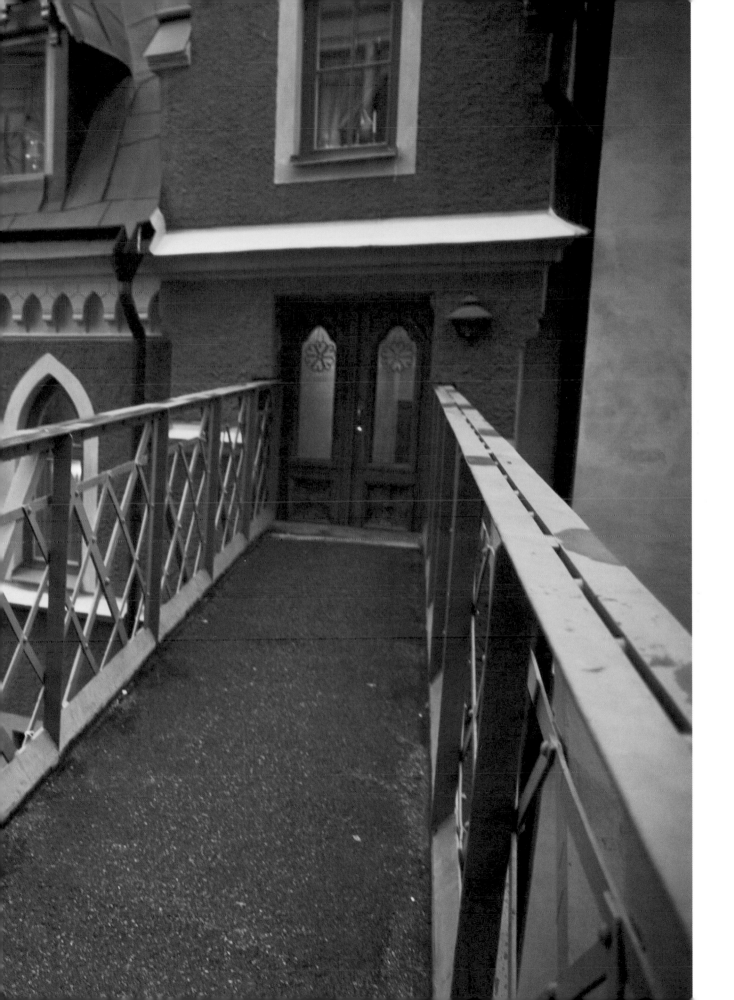

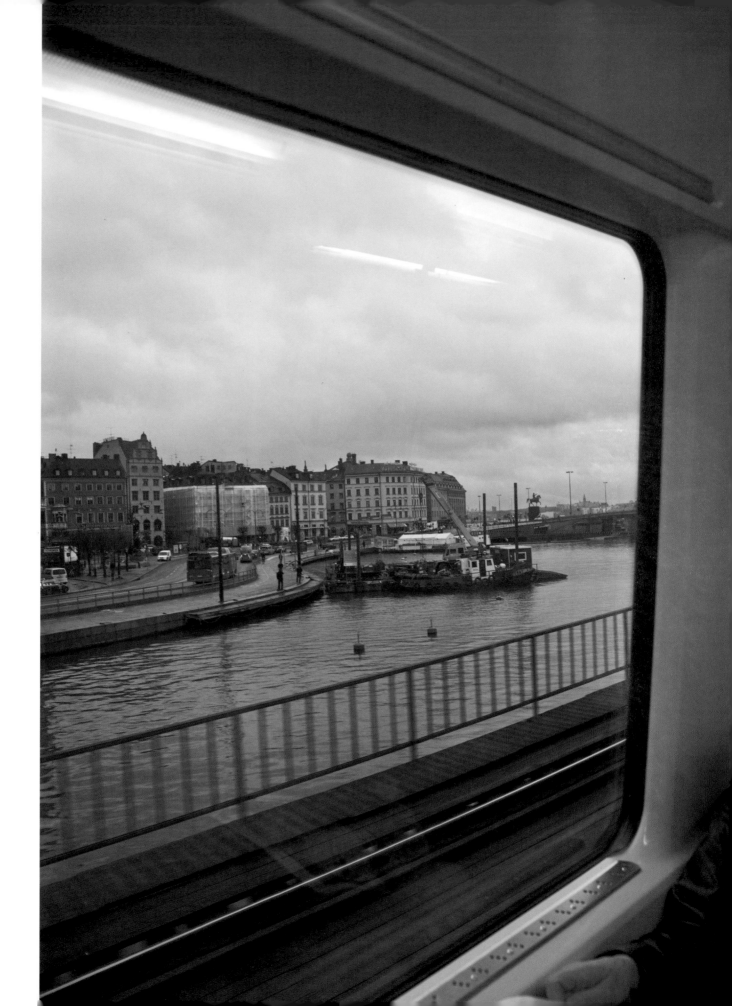

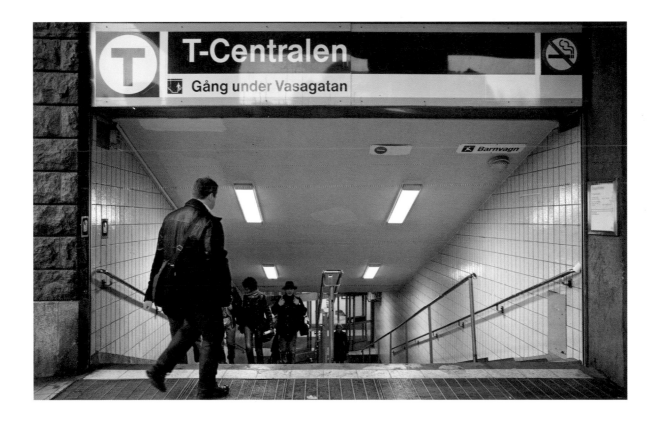

Some of Stockholm's Neighborhoods

The Stockholmers of today call their downtown area by the English word "City." It is dominated by retail, hotels, and offices. In the 1950s and 1960s this area was subject to a rather rigorous modernization. It is also the center of transport infrastructure. It is crossed by some of the main thoroughfares and motorway tunnels. The subway lines and the commuter trains meet next to the Central Railway Station. Public transport plays an important role in a city where approximately seventy percent of the population chooses to travel to and from work this way. For more than fifty years the giant public space of the subway system has become a place where artists have contributed to the aesthetic appeal by creating artwork inside the stations, sometimes covering the entire stations with artworks, transforming them into an entire world of underground palaces with a mysterious ambience.

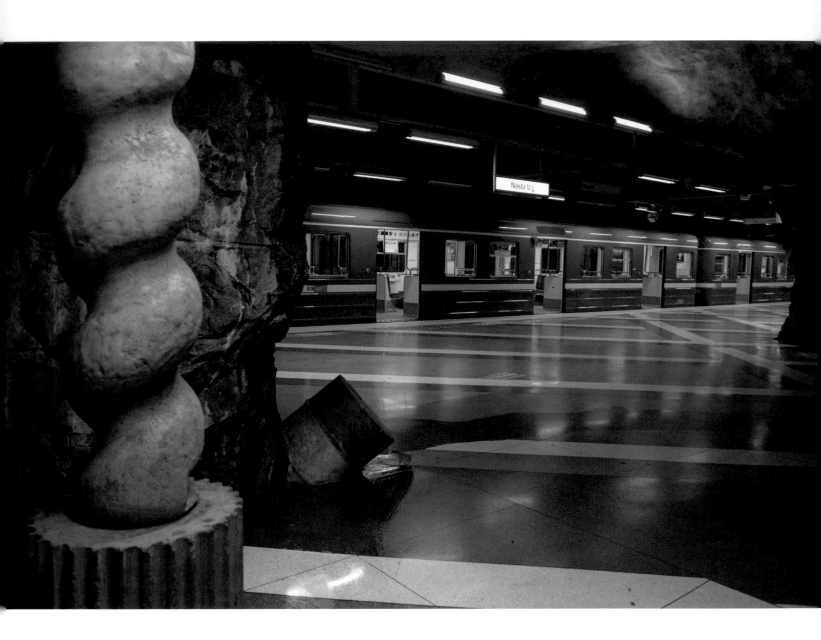

Kungsträdgården subway station, opened in 1977, sits ninety feet below sea level, nestled in solid granite. Of the one hundred stations in the subway system of Stockholm, this one contains the world's longest "art gallery" and is decorated with artwork by Ulrik Samuelson.

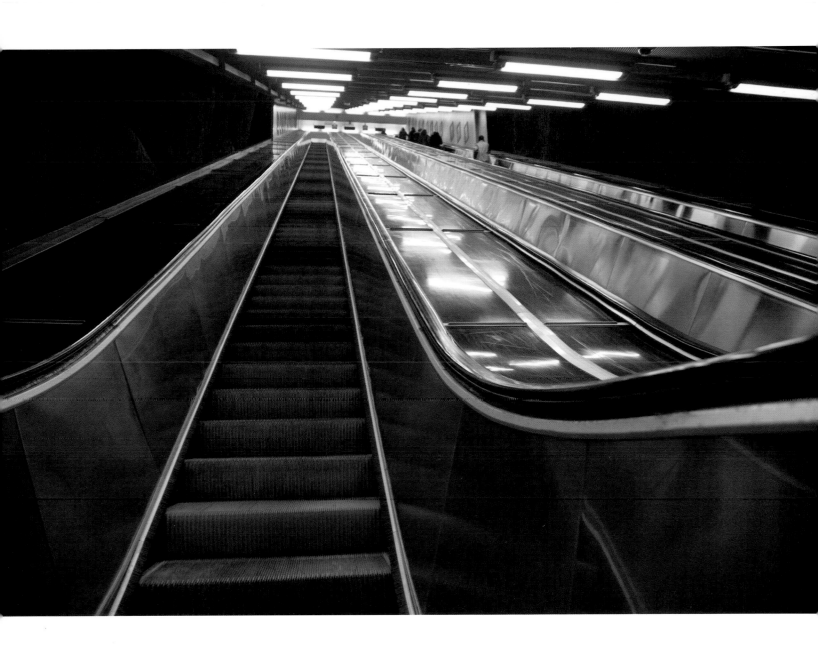

← Gamla stan

 Södermalm

milennium

/2009 • **PRIS 75 KR** • ÅRGÅNG 13 • GRANSKANDE EKONOMIJOURNALISTIK • www.millennium.se

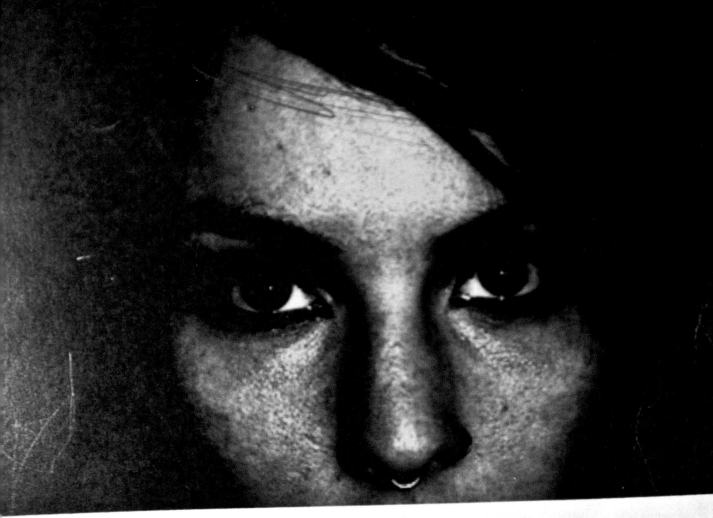

Konspirationen

mot Lisbeth

Salander

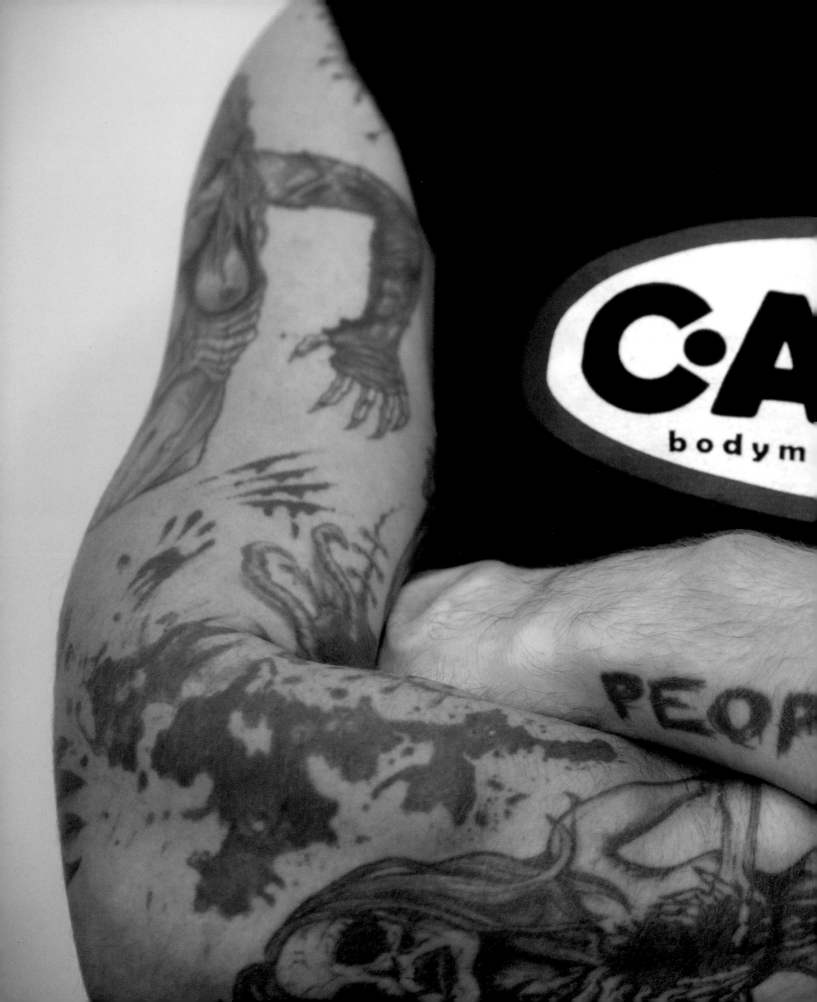

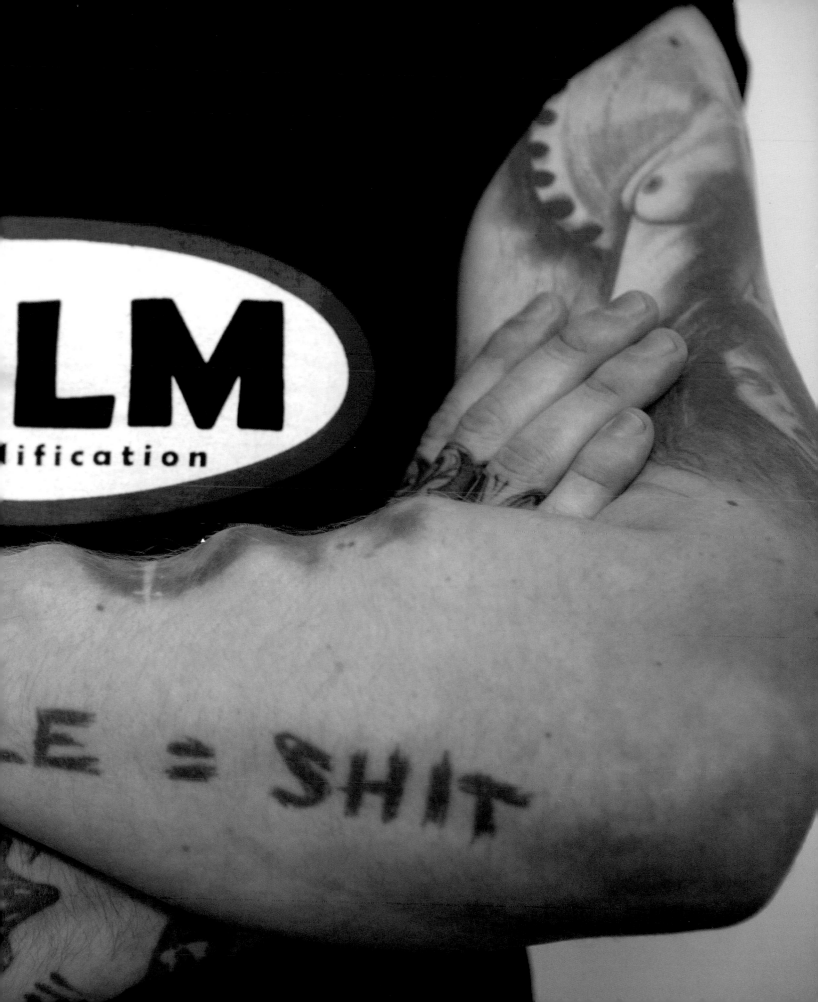

Inside one of Stockholm's more than 750 tattoo parlors.

Many tattoos serve as rites of passage.

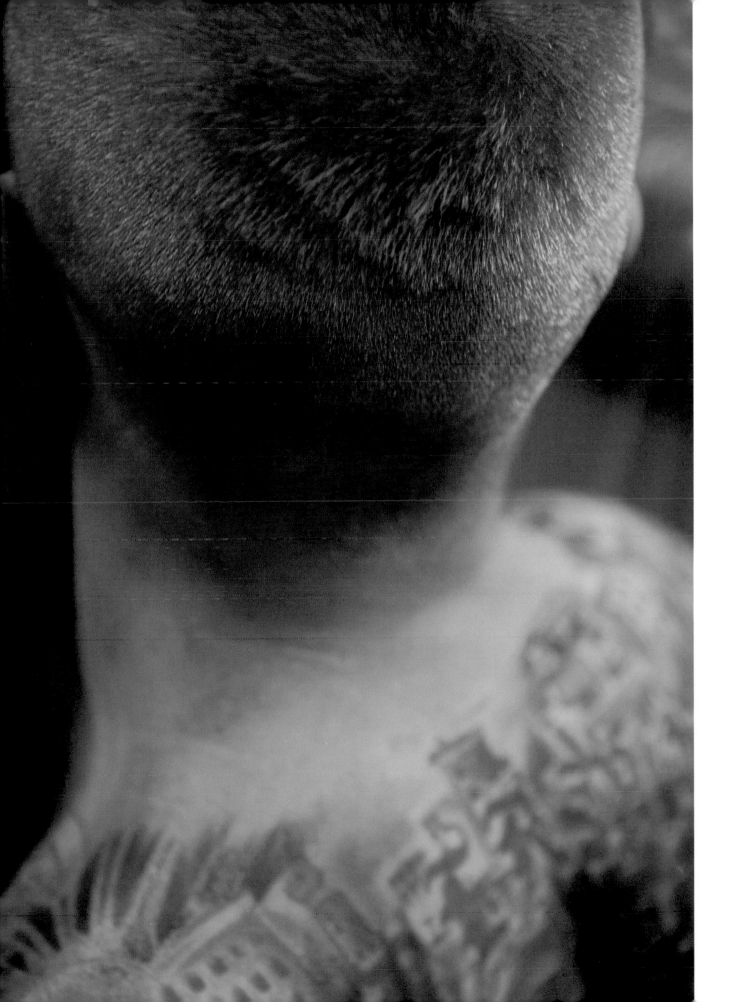

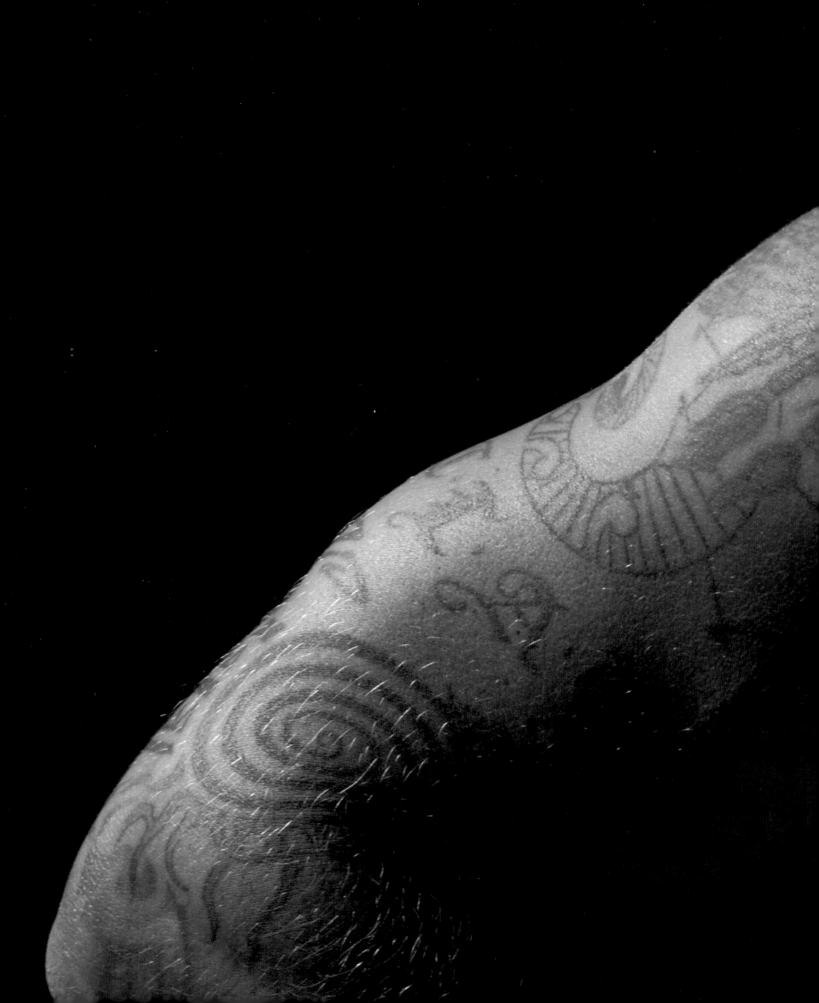

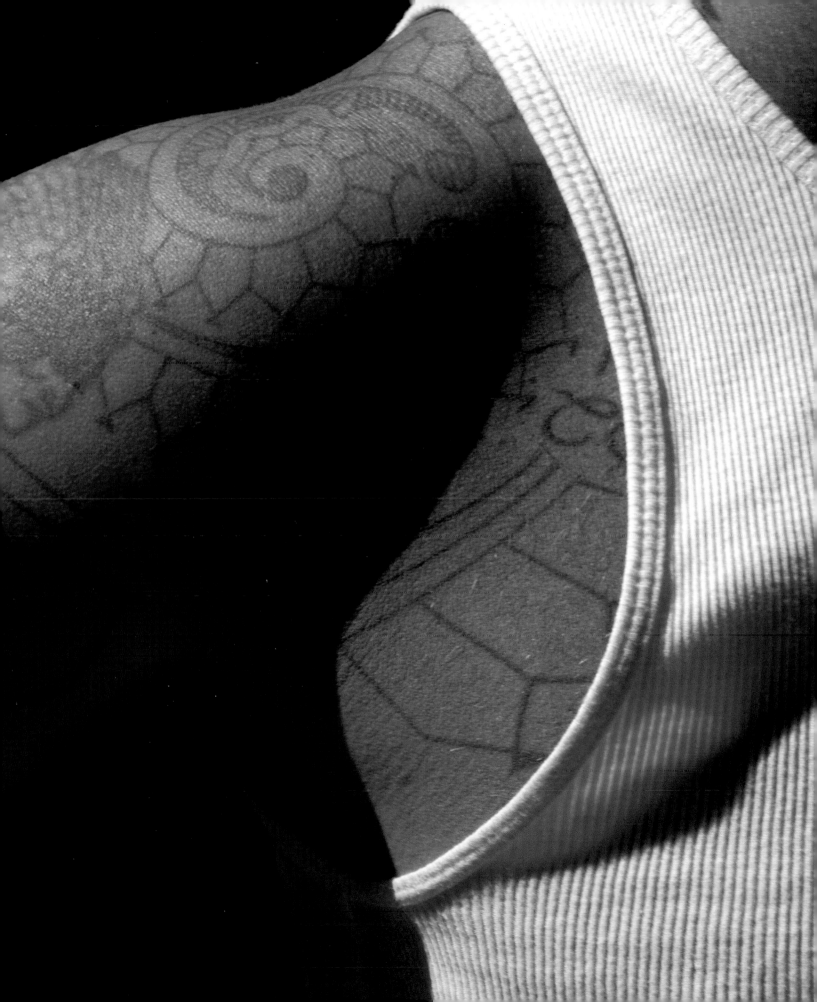

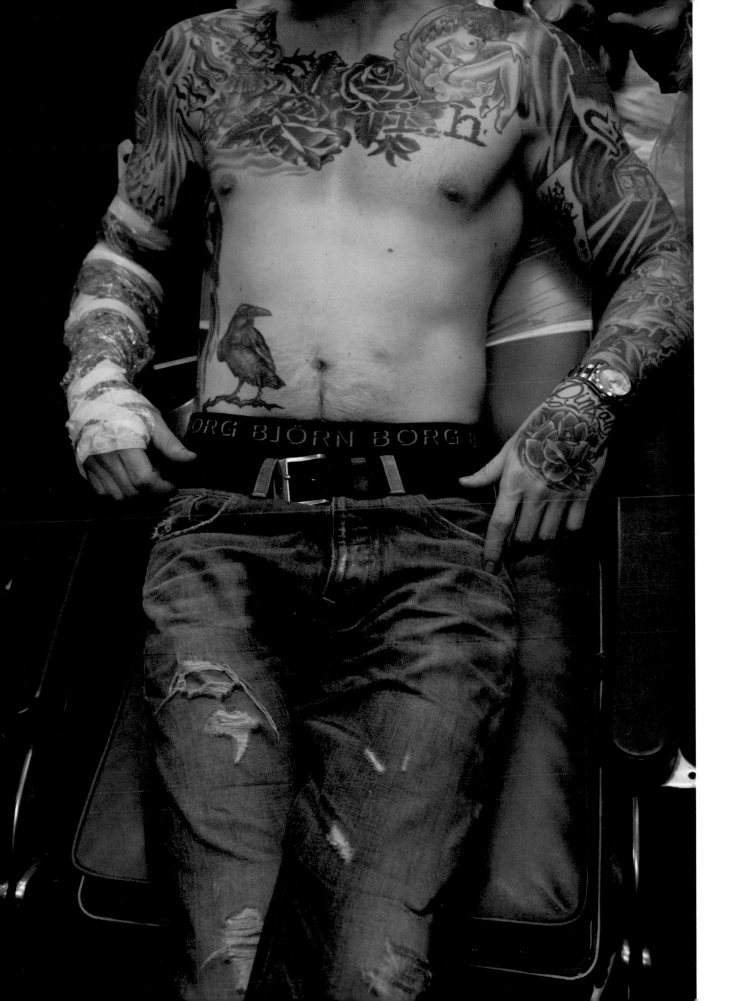

How the skin lies over the skull can make for a pretty person.

SMILEY PIERCING 595
CHEEK 675
BRIDGE 775
SKINDIVER 695/450
ANCHOR 995/700
GENITAL 750-900

AFTERCARE

H_2OCEAN 120
EMUOLJA 100

VI TAR EJ KORT

KONTANTER ÄR KONGE

PIERCING

Ebba Grön refers to a successful Swedish male punk band which existed from 1977 until 1982.

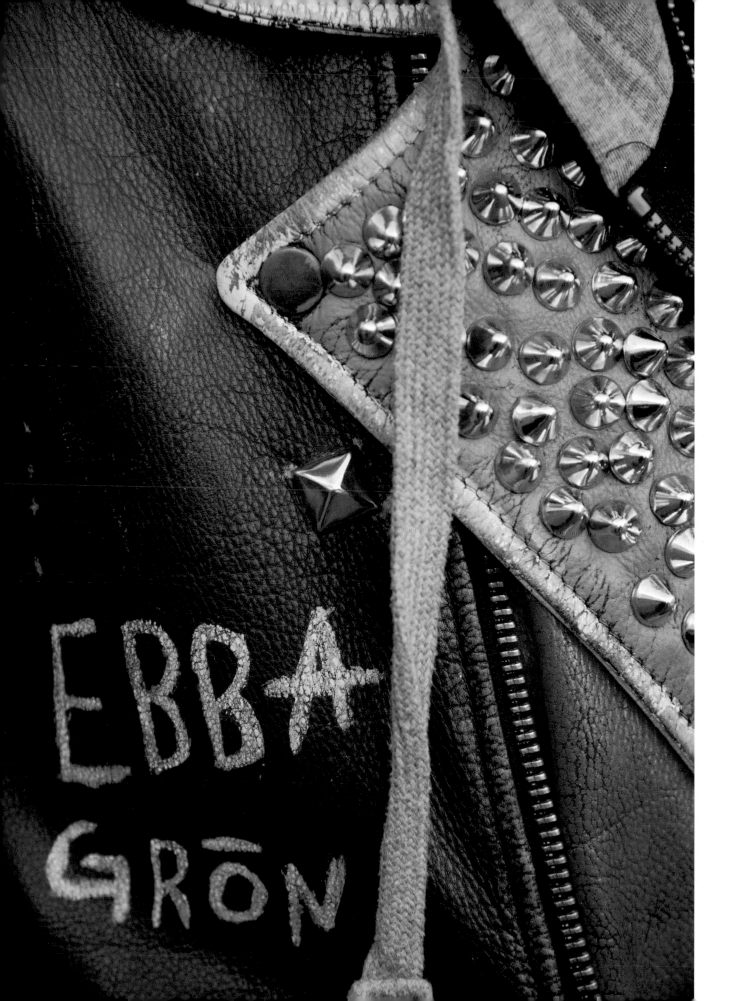

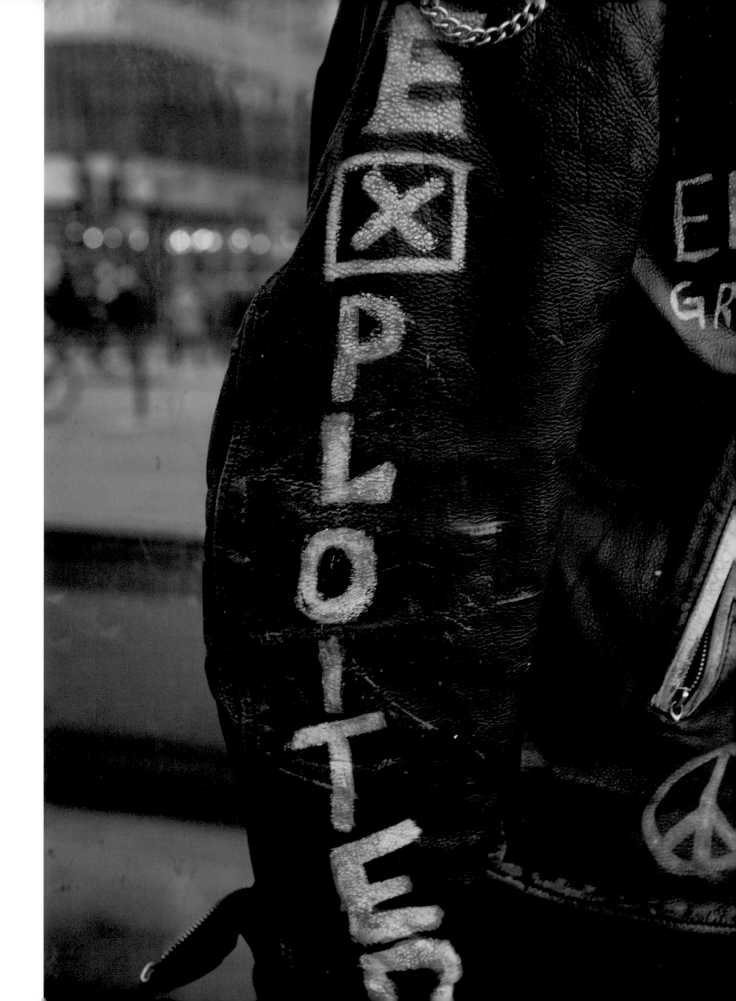

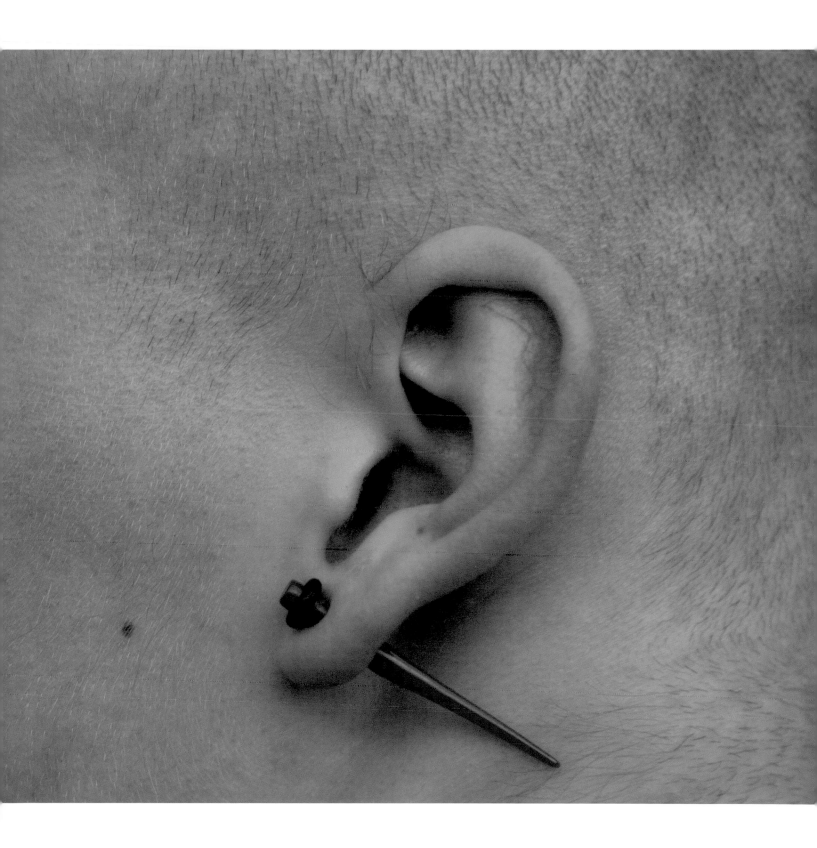

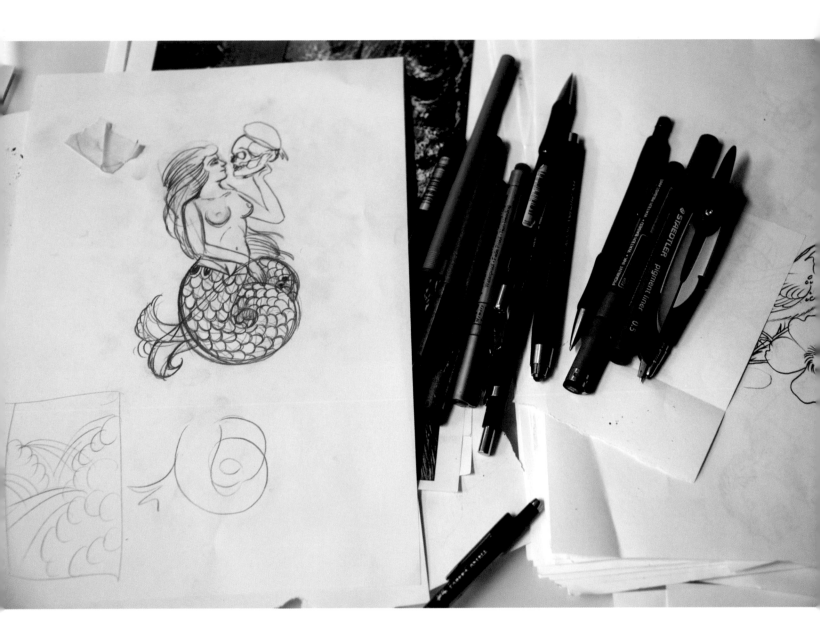

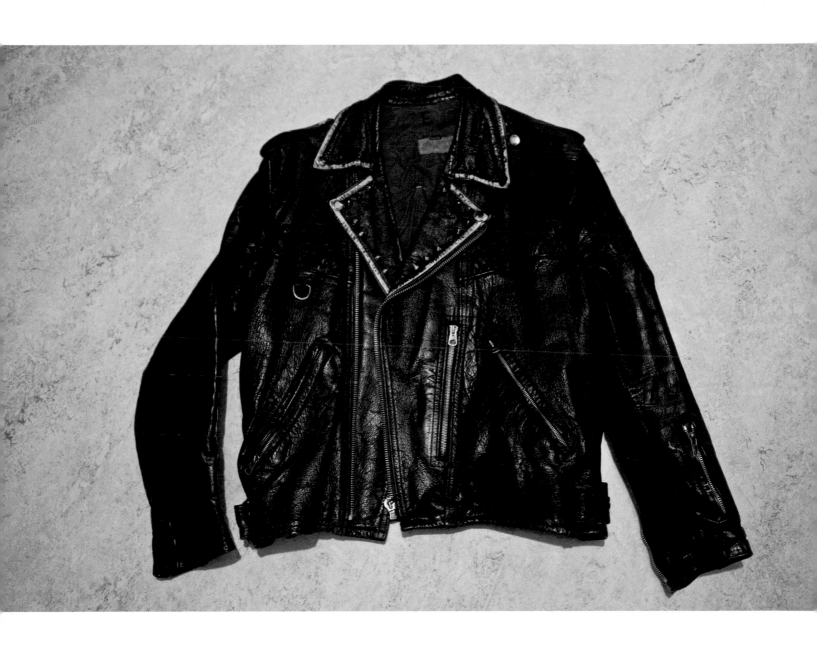

This jacket was worn by Stieg Larsson's character Lisbeth
Salander in the Swedish movie version of his novels.

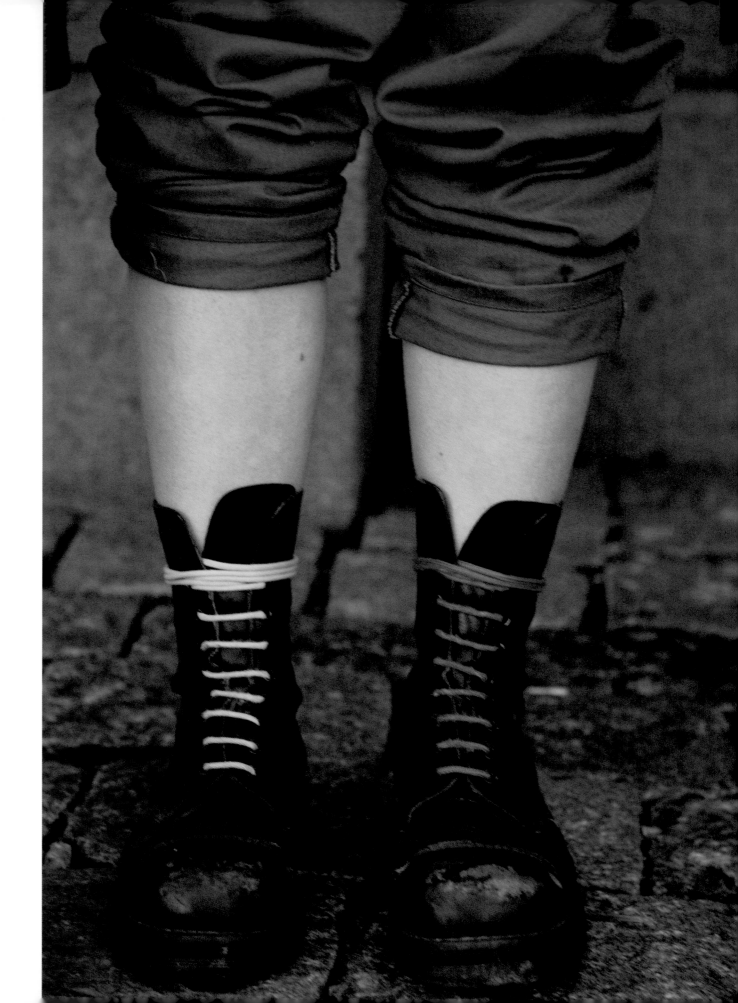

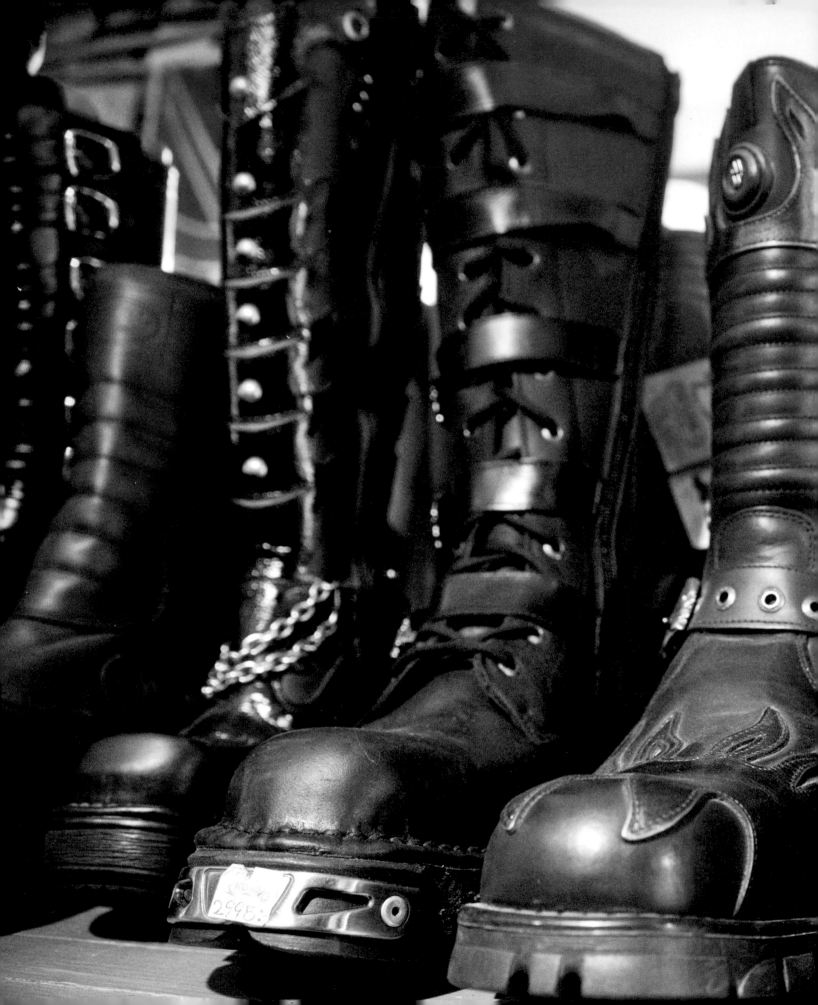

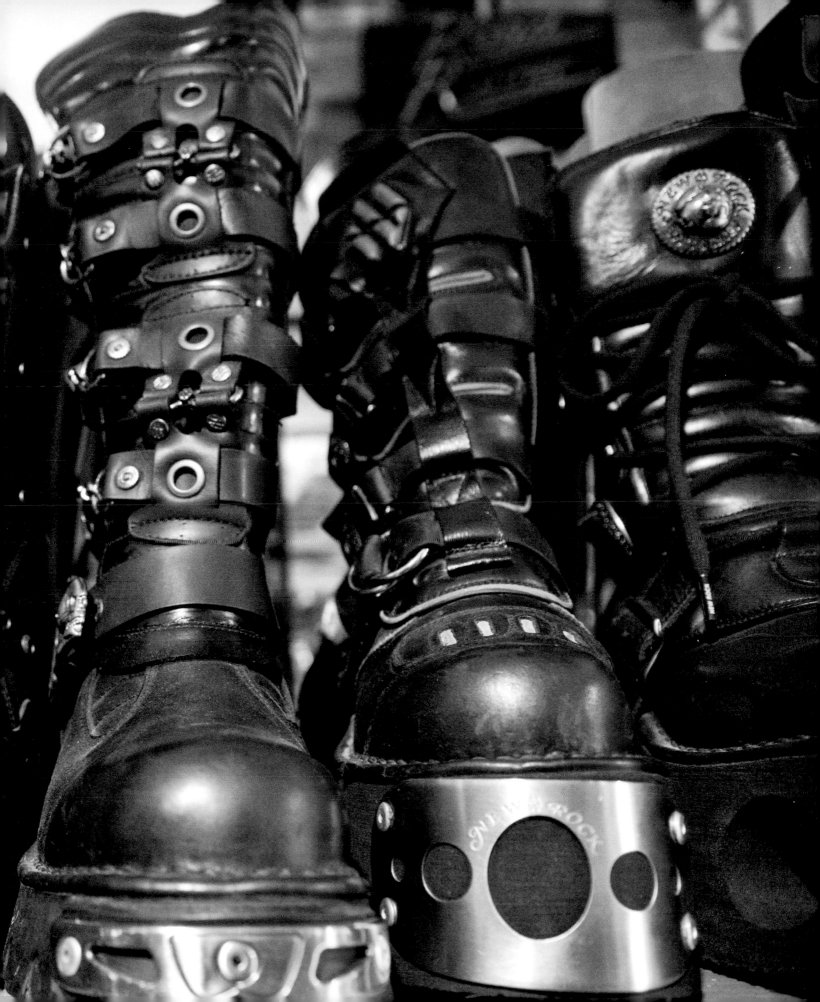

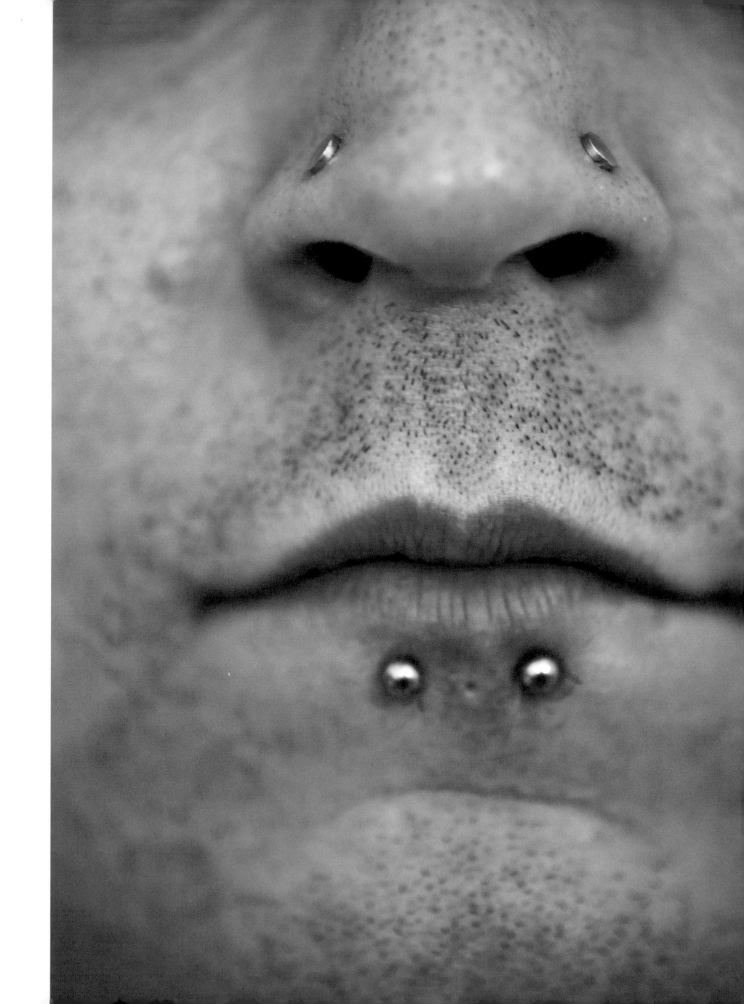

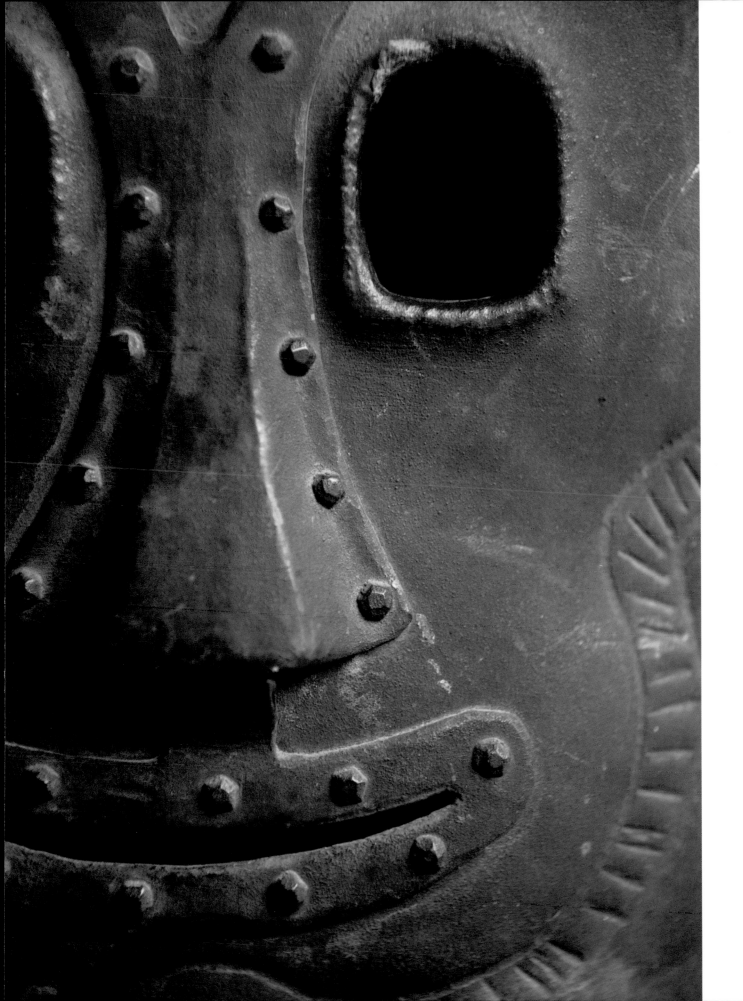

This page: On Kungsholmen Island in the west, important industries founded in the second half of the nineteenth century have given way to apartment houses and important public offices such as the City Hall, the Local Court House, and the Police Building that houses the Kronoberg Prison.

Next page: Police car opposite police station door. Handles on the magnificent entry doors to the police building at Kungsholmsgatan 37 Street are made of copper on Kungsholmen Island by artist Bror Marklund. (1907-1977). The handle to the left represents the (male) artist showing his integrity by picturing himself as a buffoon; while the one on the right has the shape of a woman.

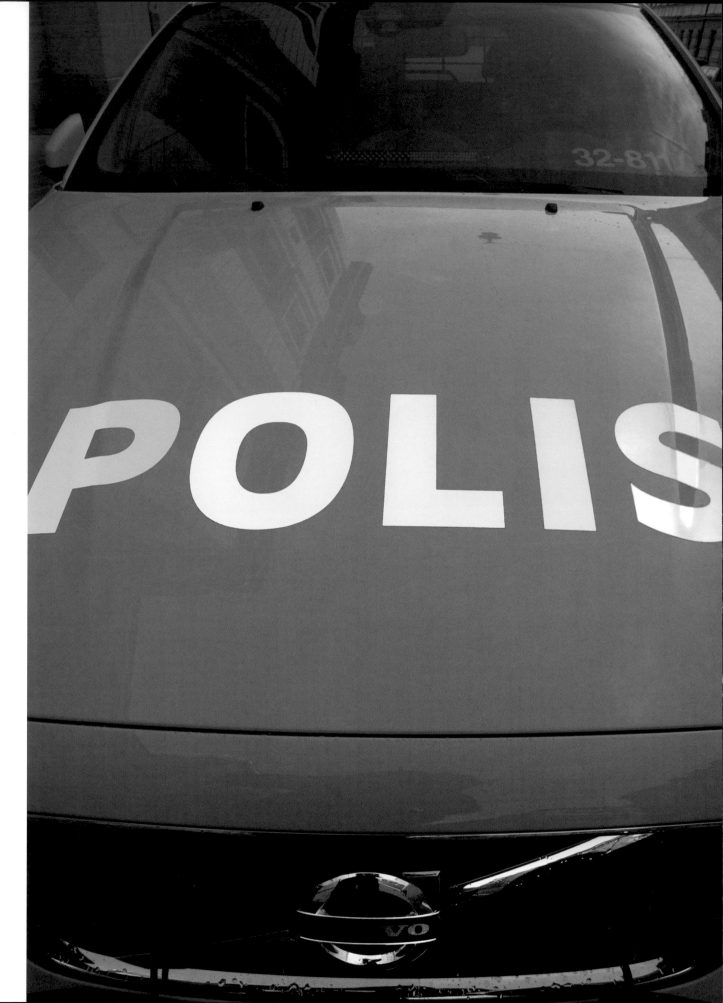

Left: Schedule for Bus 40, made famous by Stieg Larsson. **Right:** 1907 lamp that hangs inside the local Court House on Kungsholmen Island.

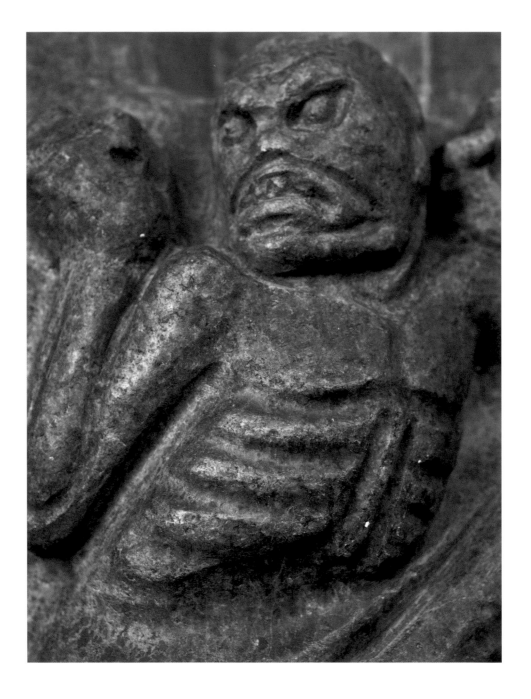

Left: Detail of series of deep reliefs in granite at the entrance of the Local Court House: *The Seven Deadly Sins*: *Wrath* (latin: ira) by sculptor Gustaf Sandberg (1876-1958).

Right: *Lady Justice* statue in chased copper by Gustaf Sandberg (1876-1958) at the entrance of the Local Court House. The national romantic building dates back to 1915 and was designed by architect Carl Westman (1866-1936).

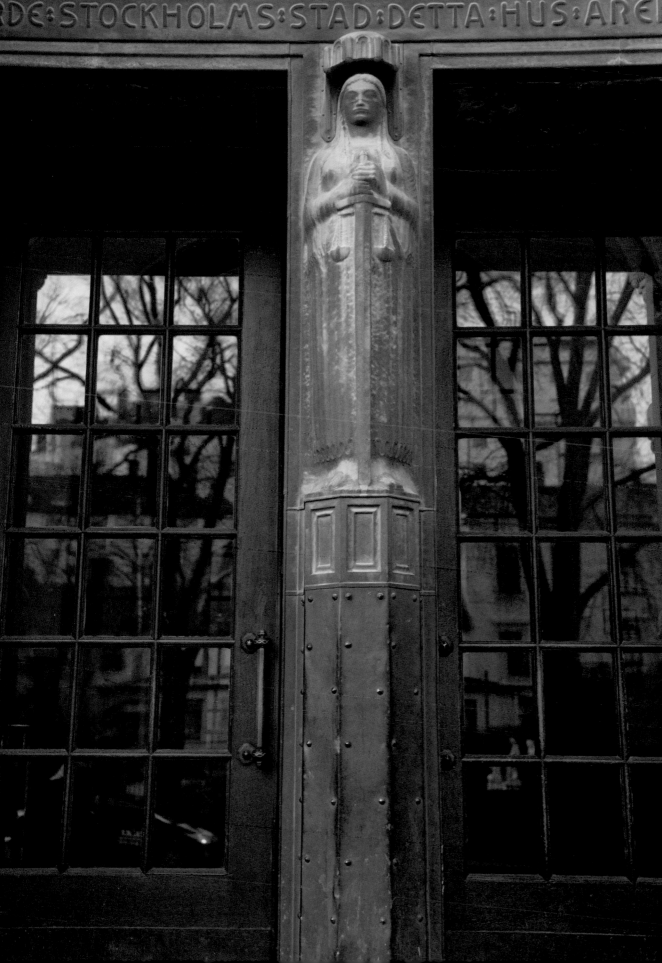

Dried flowers from The Stockholm City Museum collection similar to the species made famous in Larsson's first novel and which provided an important clue not understood until the climax of the mystery. In the story, on the first of November each year a dried flower would arrive, mystifying readers and the recipient alike.

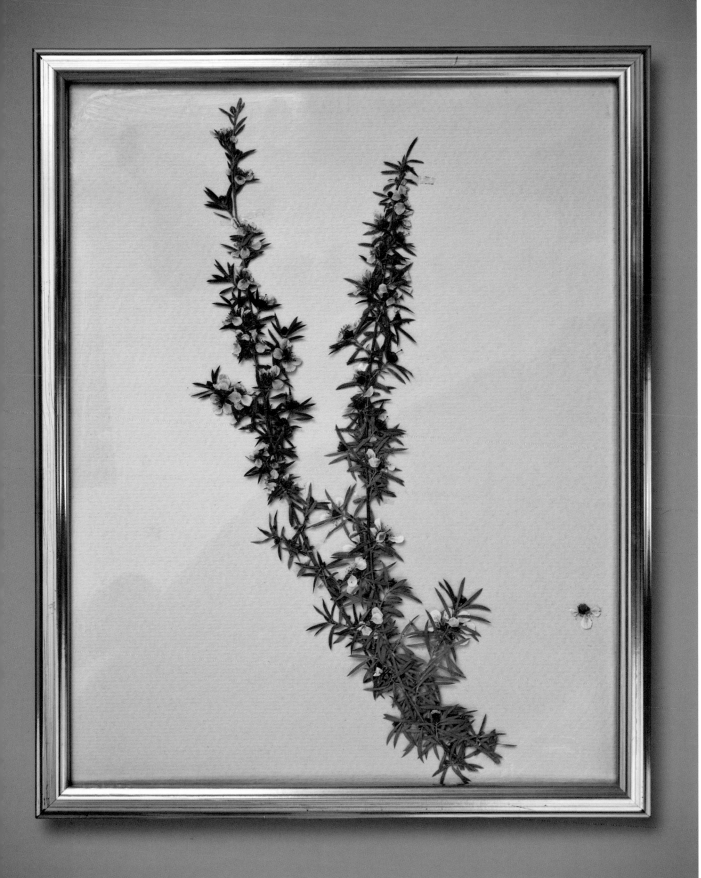

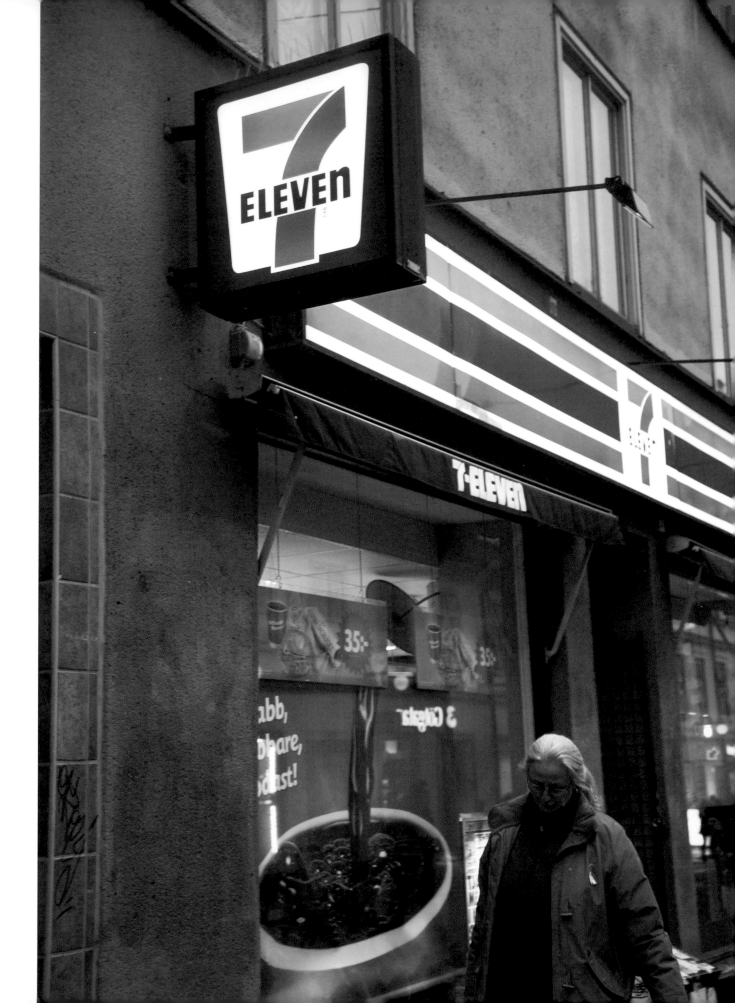

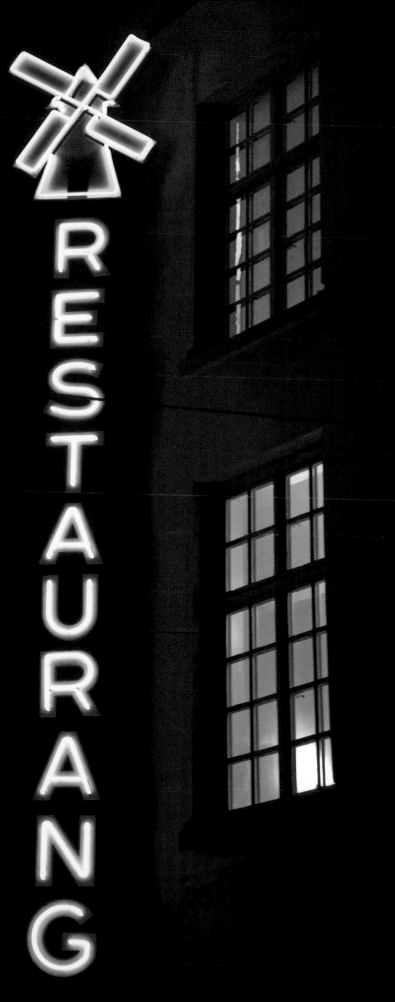

High Density

The Vasastanarea in the northern part of downtown Stockholm still has a high density of early twentieth-century residential buildings, where more than sixty percent of the apartments are studios and one-bedroom layouts, and thus perfect for the Stockholmer living in a one-person household.

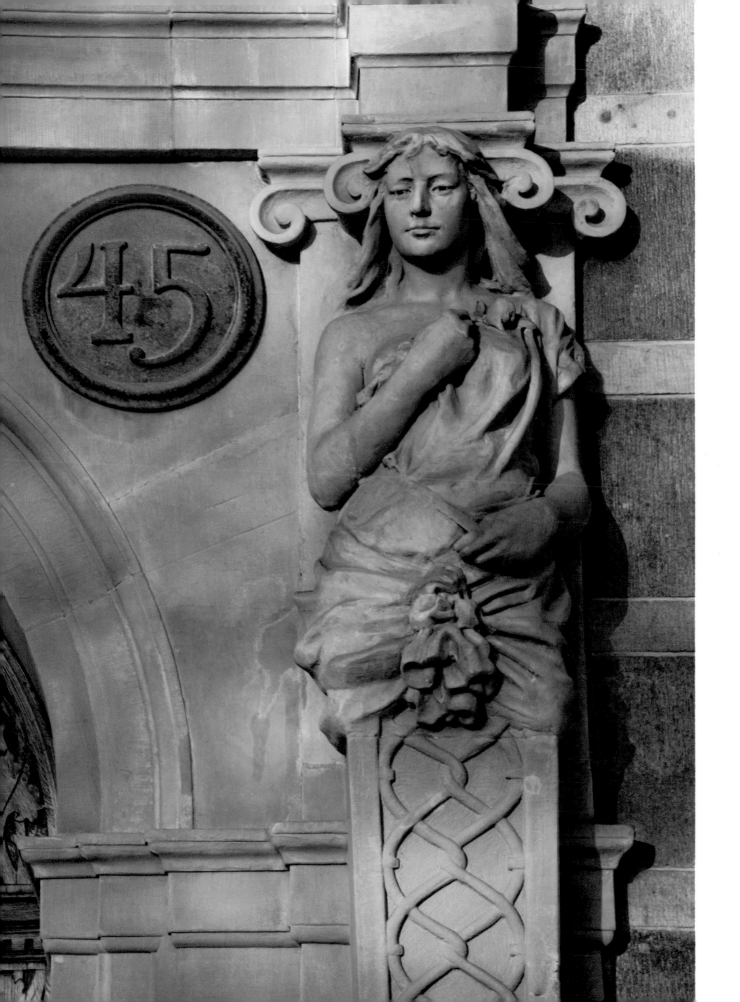

MARS

SEPTEMBER

APRIL

OKTOBER

MAJ

NOVEMBER

JUNI

DECEMBER

P148

1 2 3

4 5 6

7 8 9

A 0 B

HUSET

Civility

Östermalm makes up the eastern section of the main-land. Stately Strandvägen Street runs along the Baltic Sea, aligned with Linden trees and stunning late-nineteenth-century facades and lavish doorways. The old Crown Bakery, the Royal Dramatic Theater, and the covered market hall are some of the impressive struc-tures so frequented in this part of town.

Elegant stores and a large number of restaurants and bars complete the impression of exclusiveness and "cool" good taste. Adjacent to Östermalm lies the vast green island of Djurgården. This former royal hunting ground is an entire island full of nature in the middle of the city, with only a few hundred buildings, a bird re-serve, and most important, Skansen, the open-air mu-seum that gives visitors the opportunity to walk back into history as they stroll among dwellings with regional designs that represent indigenous architectural styles.

Motorcycles feature large in the Larsson novels and in the lives of most Stockholmers, as well.

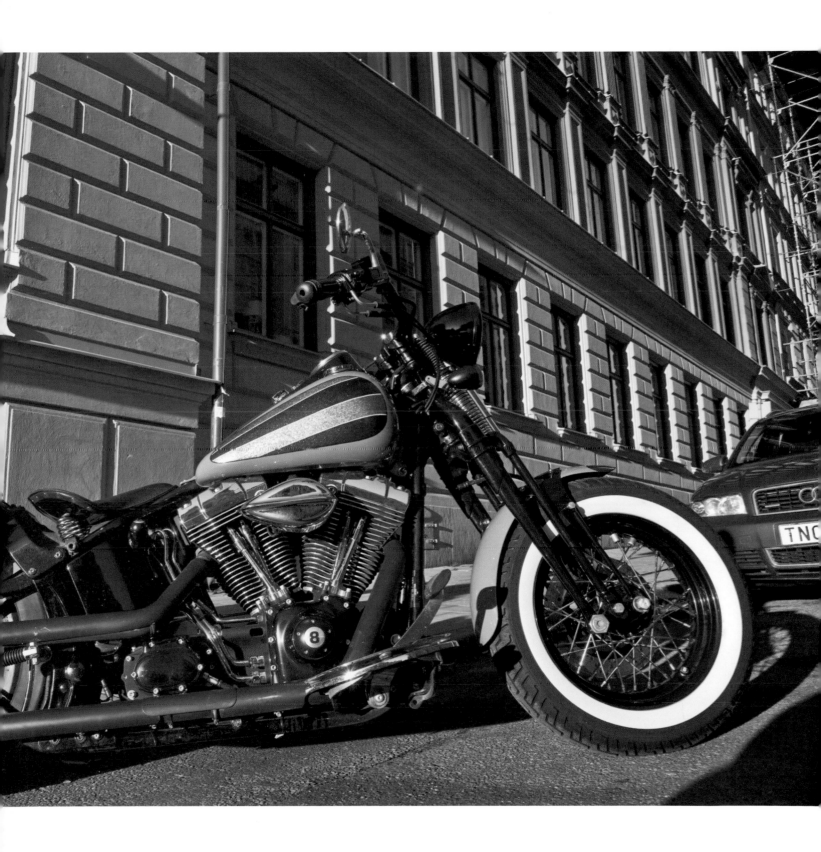

Interior from Mellqvist Kaffebar in Hornsgatan, one of Stieg Larsson's favorite cafes in the city that loves coffee.

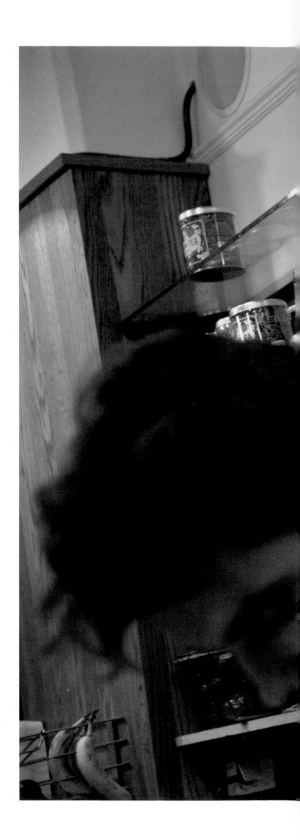

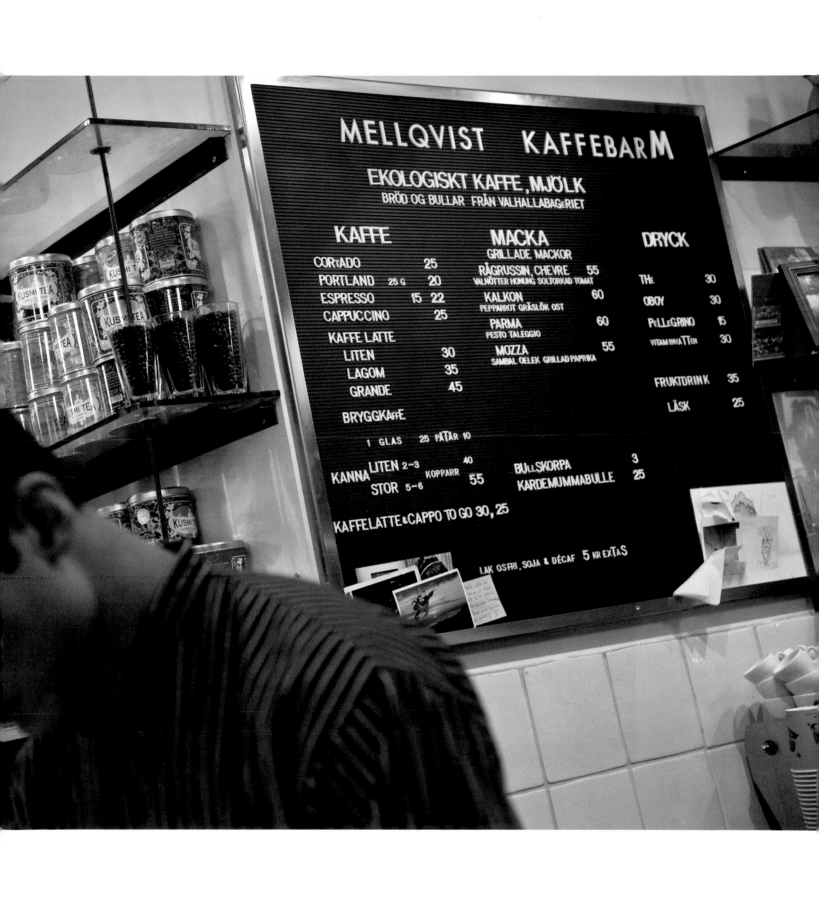

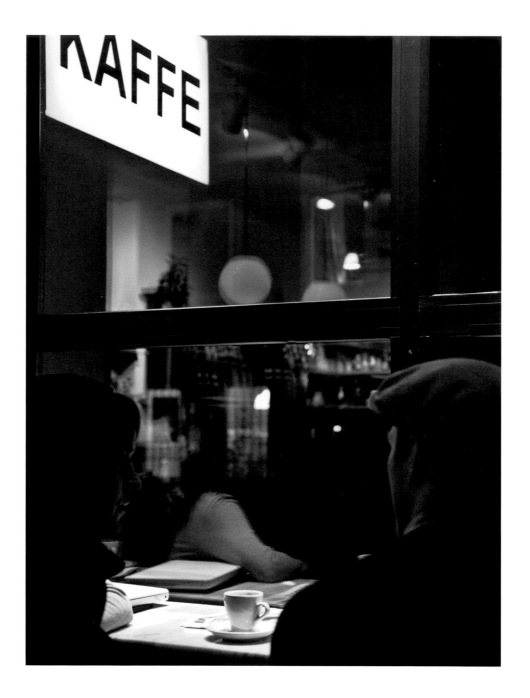

Left: Kaffe coffee store on Sankt Paulsgatan Street opened in 2009 when the owner had moved on from Kaffebar. They serve the same delicious espresso and grilled cheese sandwiches that Stieg Larsson favored.

Right: Cheese sandwiches with Swedish Västerbotten cheese have become a local favorite since Larsson published his novels, where they provided a staple meal for his characters.

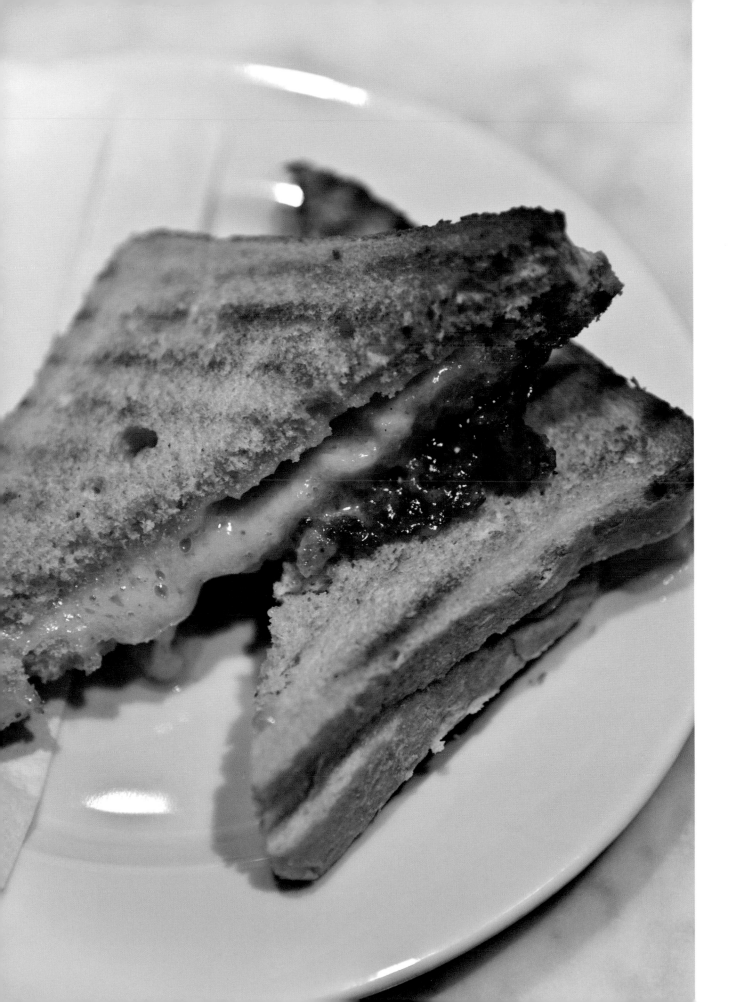

Through Stieg Larsson's Eyes

Stockholmers are readers, thinkers, coffee drinkers and
these elements play a large role not only in his novels but
those of other contemporary Swedish novelists as well.

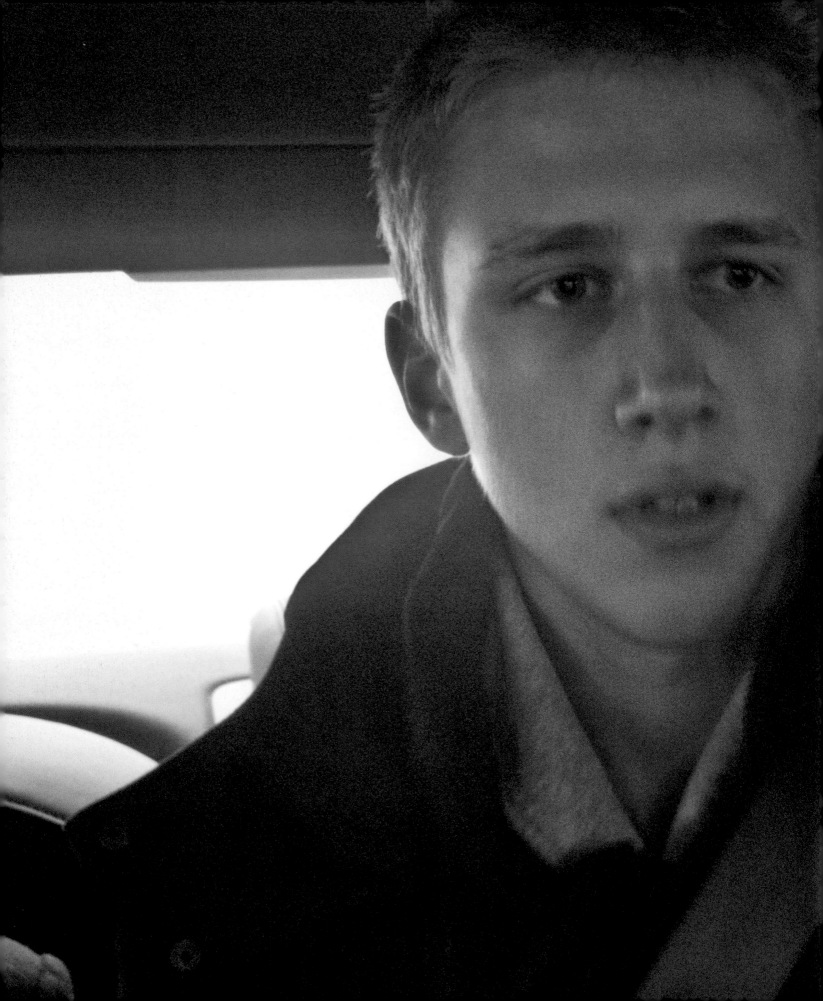

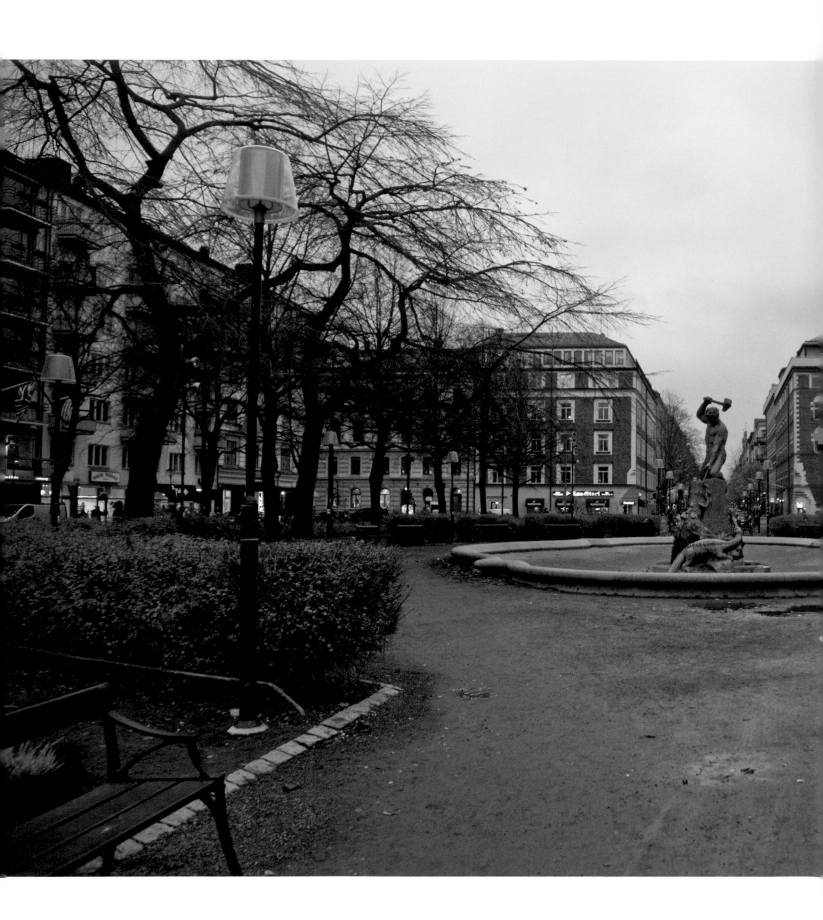

Mariatorget Square in western Södermalm, notable because the square is dominated by Anders Wissler's 1903 bronze statue of the god Thor. Larsson was known to spend hours in this park reading and resting and was named as a meeting place in his books.

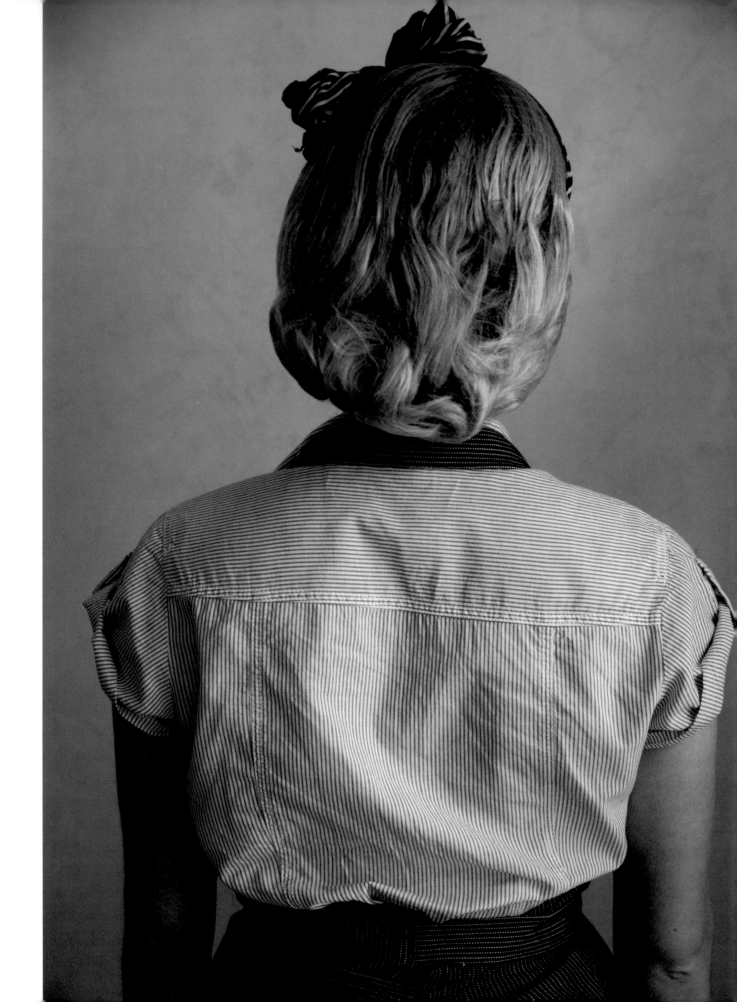

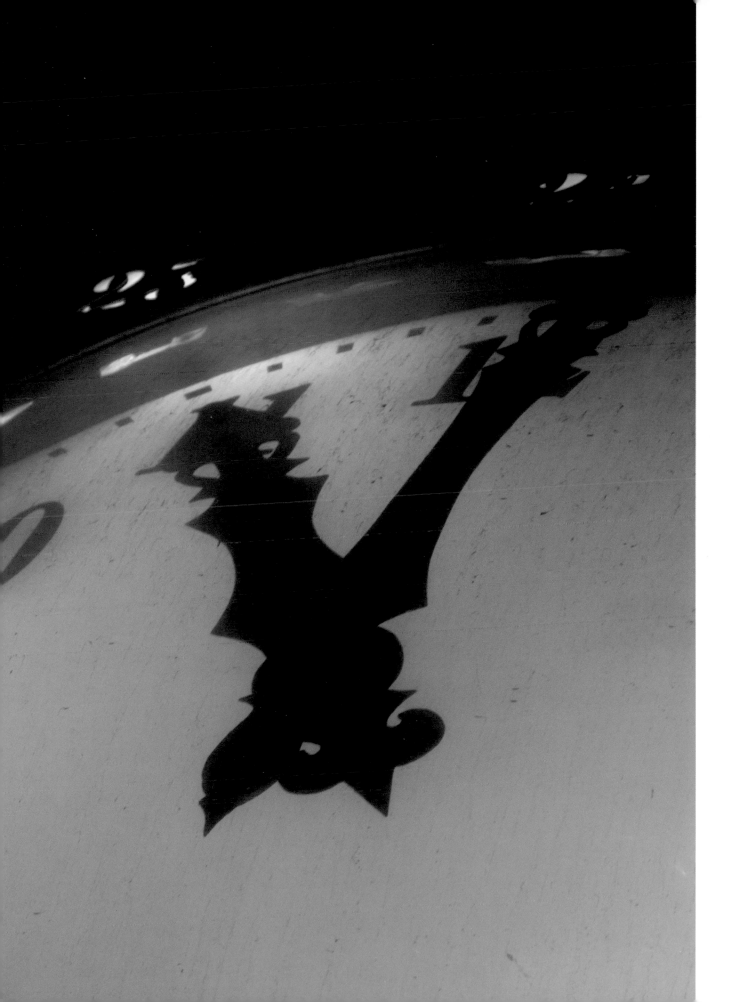

P179

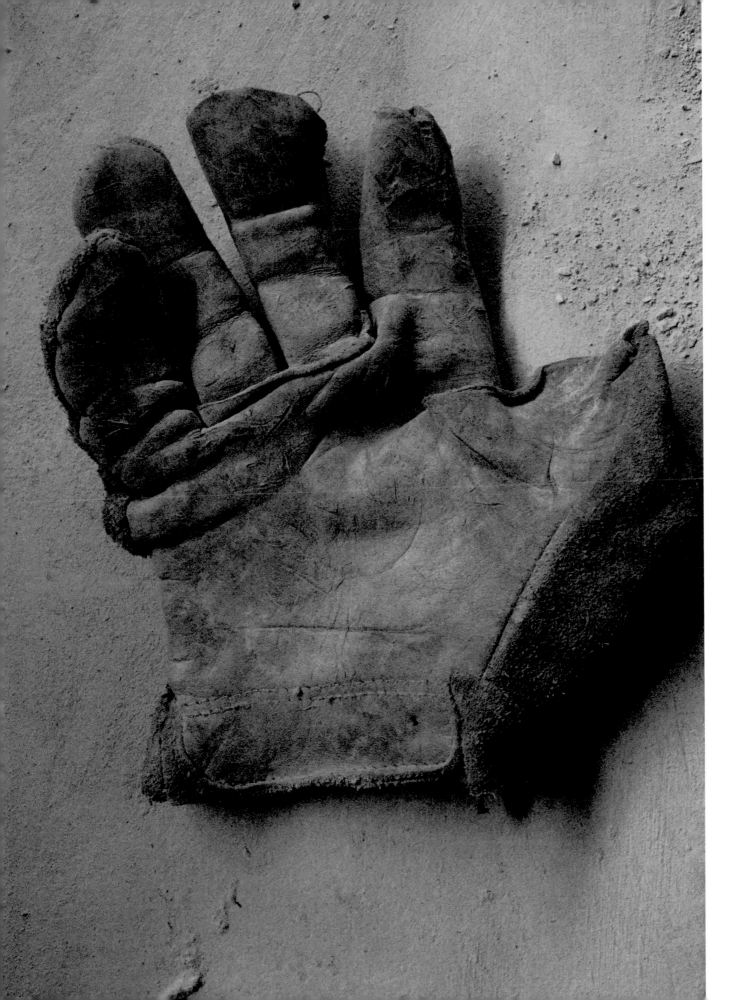

Generation to Generation

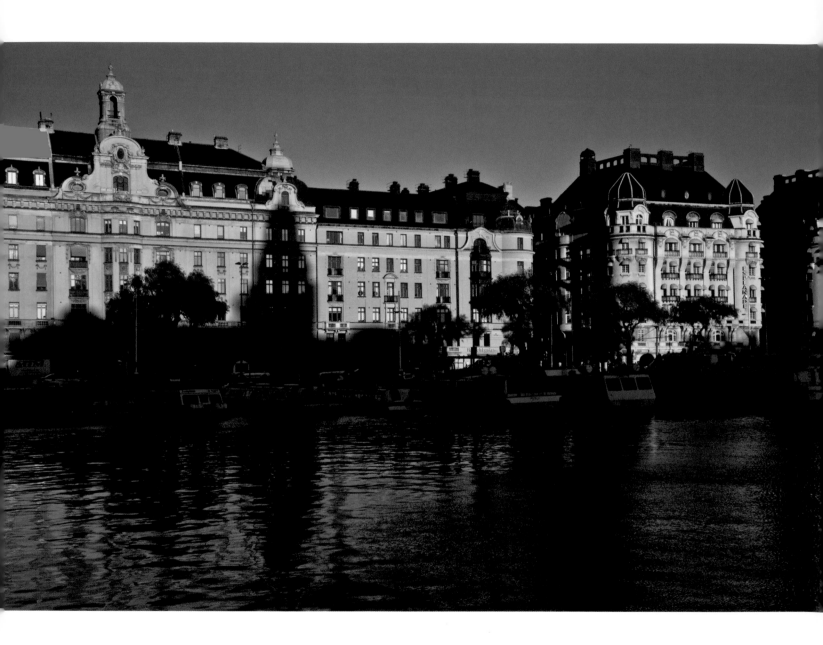

Numbers 1-7 Strandvägen Street in late afternoon.

The white passenger ships leaving Strömkajen Pier in front of the Grand
Hotel for the Stockholm archipelago, an area of more than 30,000 granite
islands. This one may be on its way to Sandhamn, where Stockholmers
often have little cottages that pass from generation to generation and
where Stieg Larsson first started writing his book trilogy when
vacationing in the archipelago in the summer of 2002.

Index

Acknowledgments

THANK YOU to Elisabeth Daude, Patrik Janson, Susanne Juul, Jannie Haagemann, Camilla Alfthan, Johan Tegel, Johan Sörman, Luciano Baldini, Leo Berglund, Niklas Piers, Daniella Illerbrand, Vincent Lefeure, Matilda Lindvall, Tito Frez, Tomas Gustavsson, Mathias Andersson, Vasa Museum, Björn Olsson, Caroline Bäcker, Eva Dahlgren, Annette Holmberg, Pär Jonasson, Rune Orloff, Danyel Couet + F12, Filip Odelius, Tuomas Liewendahl, Jörgen Andreasson, Mathias Dahlgren, Lisa Elmqvist, Andreas Moberg, Niki Sjölund, Isaac Pineus and Andrew Duncanson and Modernity, Randy Jämtlid, Salvation Tattoo, CALM Body Modification, Yiva Vitorovic, Skansen, Christina Hamnqvist, KC Wallberg, Christian Petré, Clarion Hotel, Matias Ibanez, Pro Center, Maria Millqvist Englundh, Erik Svedin, Stockholm Bikes, Christopher Bastin, Petra Gamerdinger, Adam Torsholm, Stefan Karlsson, Andre Landeros Michel, Ida Rislöw, Lisa Ericson, Miriam Parkman, Pärlans Konfektyr, Nils Åberg, Efva Attling, Eric Langert, Ann-Christine Lindberg, Tomas Gustavsson, Fredrik Nelderup, Tanya Nanette Badendyck, Helena Lorio, Henrik Larsson, Fredrik Andersson, Alexandra, Anne-Sophie Hammar, Stina Bengtsson, Rickard Gustafson, Jørgen Storm Rosenberg and Joachim Olausson.

Our friends at VisitSweden and Stockholm Visitors Board: Magnus Lindbergh, Christina Guggenberger, Henrik von Arnold, Peter Lindqvist, Lotta Thiringer, Annika Benjes, Maria Winterstrid, Emilia Björk and Andre Landeros Michel. Our friends at Fotografiska: Jan Broman, Per Broman, Charlotte Wiking, Michelle Marie Roy, Anne-Sophie Hammar, Pauline Benthede, Mao Abrahamsson, Anna Hasselström. The generosity of Audi: Irene Bernald, Daniel Sjögren, Patrick Smith. Our friends at the City Museum of Stockholm; Cecilia Törnqvist, Sara Claesson and everyone at SAS Airlines for their human spirit in business; and to Magdalena Hedlund at the Hedlund Agency for her kindnesses throughout the editorial and production process.

Photography Credits

Christopher Makos: Pages: 4-5, 6-7, 22-23, 28, 29, 32, 33, 34, 35, 38, 39, 44, 45, 47, 48, 49, 50, 51, 56-57, 64, 65, 69, 74, 76, 77, 79, 83, 86, 88-89, 90-91, 92, 93, 100, 101, 102, 104, 106-107, 108,120-121, 122, 123, 127, 131, 132, 133, 138, 139, 140, 141, 142, 143, 150-151, 153, 156, 158-159, 164, 165, 166, 168-169, 172-173, 174-175, 176-177, 182, 183, 184, 186, 187.
Paul Solberg: Pages: 1, 2-3, 24, 25, 26, 27, 30, 31, 32, 33, 34, 35, 37, 40, 41, 42, 43, 46, 52, 54-55, 59, 60-61, 62-63, 66, 67, 68, 70-71, 72-73, 78, 80-81, 82, 84, 87, 94-95, 96-97, 99, 103, 109, 110, 112, 113, 114-115, 116, 117, 118, 119, 124, 125, 126, 128-129, 130, 134-135, 136, 144-145, 147, 148, 149, 154-155, 160-161, 162-163, 167, 170-171, 178, 179, 180, 181, 185, 188,189.